THE MANGROVES

Photographer and Author ~ Rick Bopp

THE MANGROVES
 Photos by Rick Bopp

Copyright © 2013 by Rick Bopp

CREATESPACE Softcover Edition

Printed in the United States of America

First Printing 2013

ALL RIGHTS RESERVED. No part of this publication may be reproduced or transmitted in any form or by any electronic or mechanical means including photo copying, recording, or in any information storage or retrieval system now known or to be invented, without permission in writing from the publisher or the author.

ISBN: 978-1493524686

Photographer and Author: Rick Bopp
For more information: rickbopp@gmail.com

Photos available at rickbopp.com

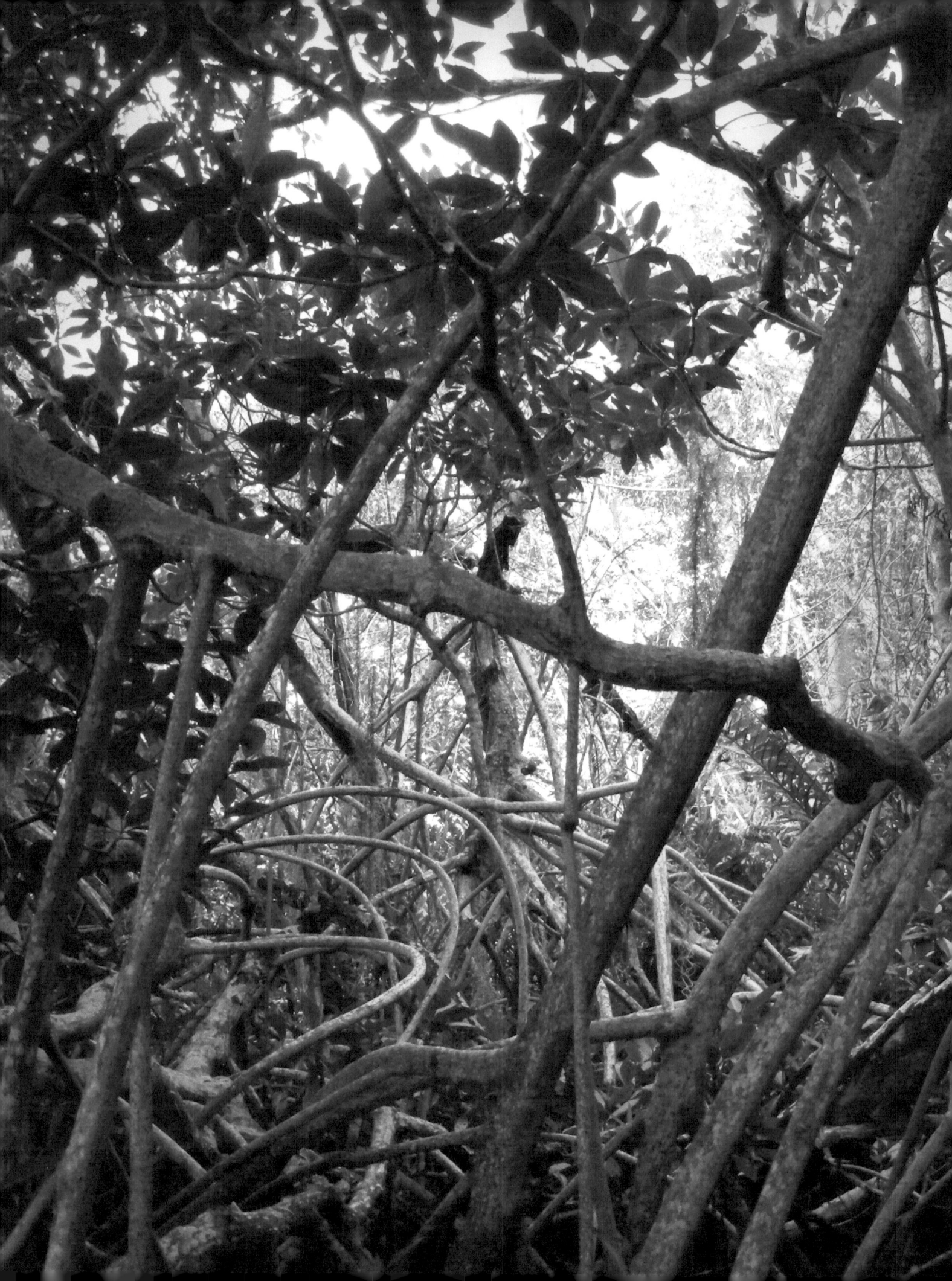

Welcome to the incredible world of wetland and coastal mangroves. Black, white and red mangrove species are the visual subject of this book. Estuaries and waterways in the subtropical and warmer climates abound with expansive stands of these vigorous 'superbushes'. There you find them relentlessly wading out from shorelines, as the natural borderlines of our coastal waterways.

A closer look will reveal intricate networks of prop roots and upper branches. As mangroves grow they tenaciously weave support frames able to withstand hurricane winds and strong tidal surges. They also function as a sort of natural seawall, reinforcing shorelines and reducing beach erosion.

Branches and foliage above the waterline offer nesting and perches for a diverse variety of birds, such as herons, anhingas, wood storks and ibis. Below the surface, roots provide protective cover. The mangroves become nurseries for many species of fish including snook and tarpon. In addition, microorganisms, barnacles and shellfish live among the extensive underwater root forests created by the mangrove stands.

Mangroves not only endure, but thrive on the salty and freshwater mixtures of brackish tidal waters. Through a natural osmosis they convert saltwater into freshwater.

This book is a tribute to these amazing wetland trees and a study of the mangroves as natural works of art. Enjoy this aesthetic glimpse into the amazing world of the coastal mangroves.

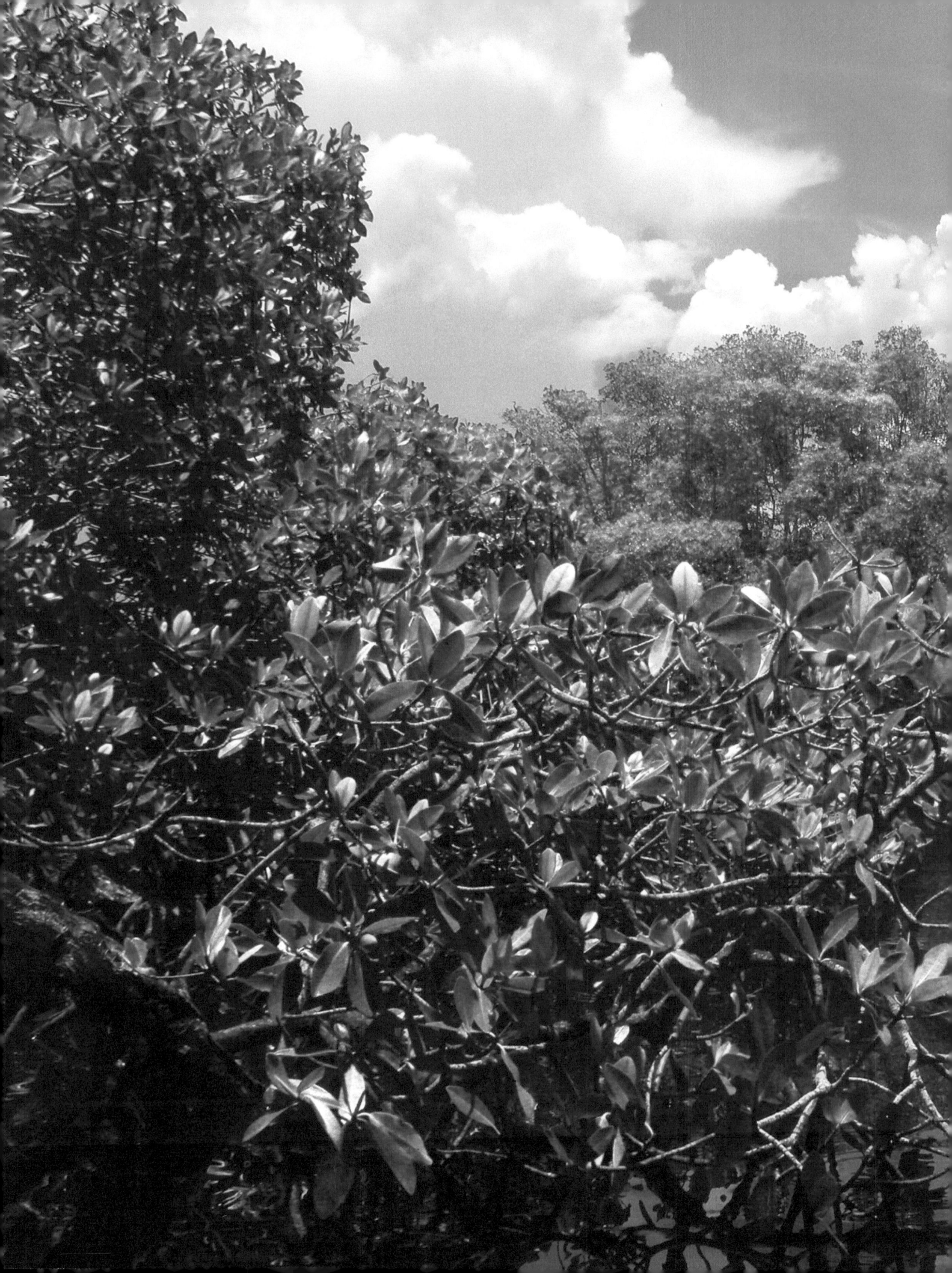

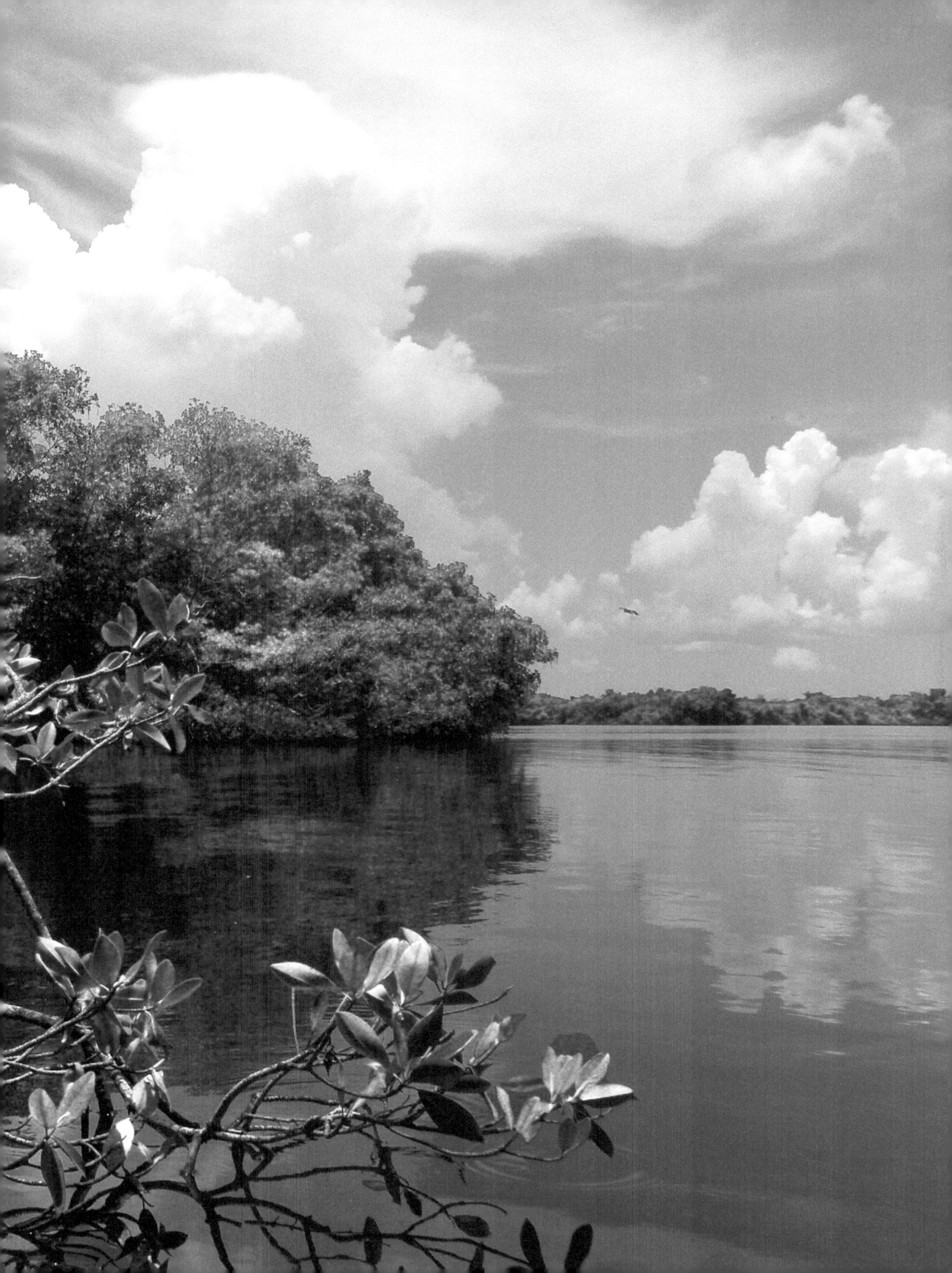

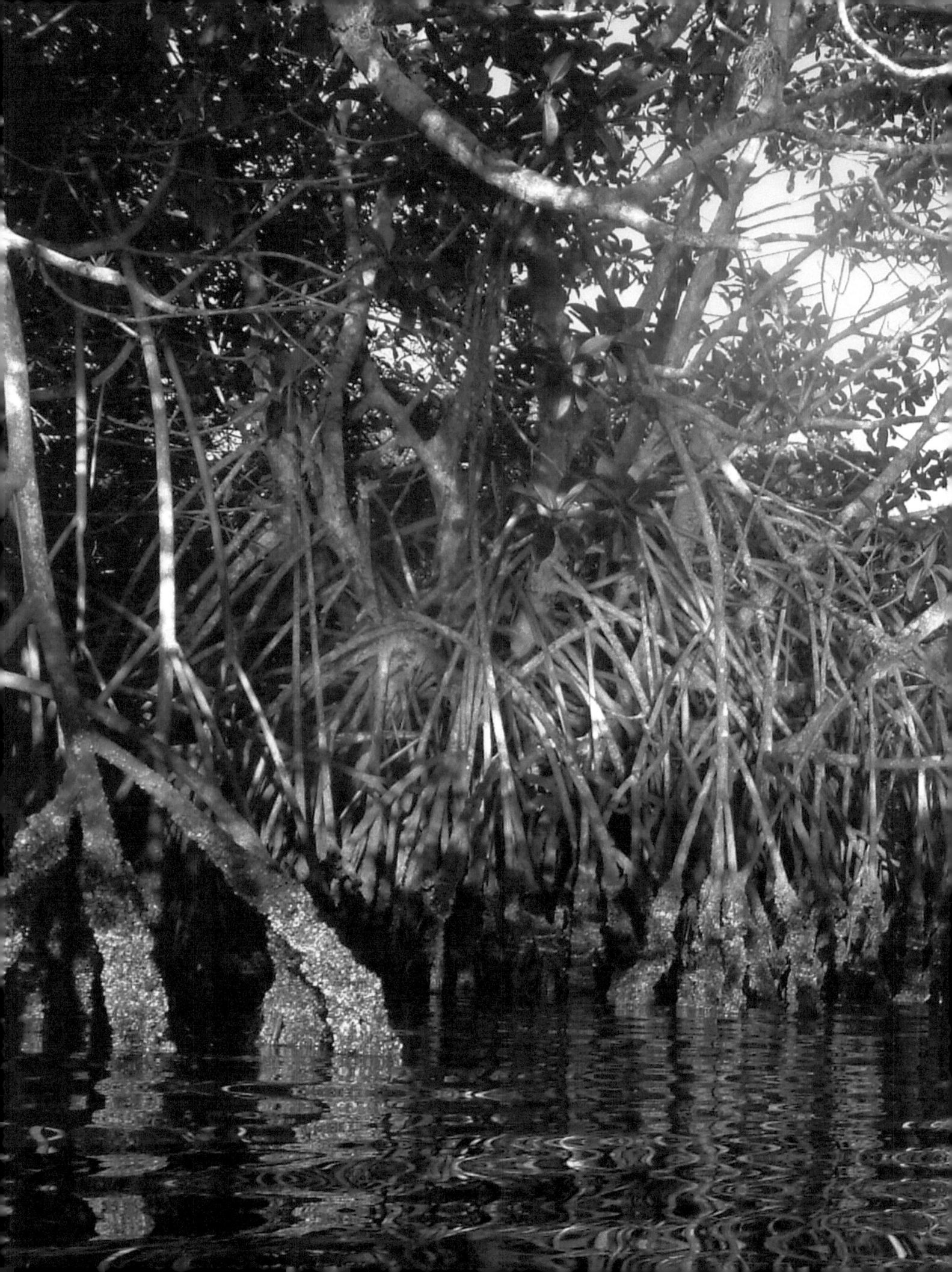

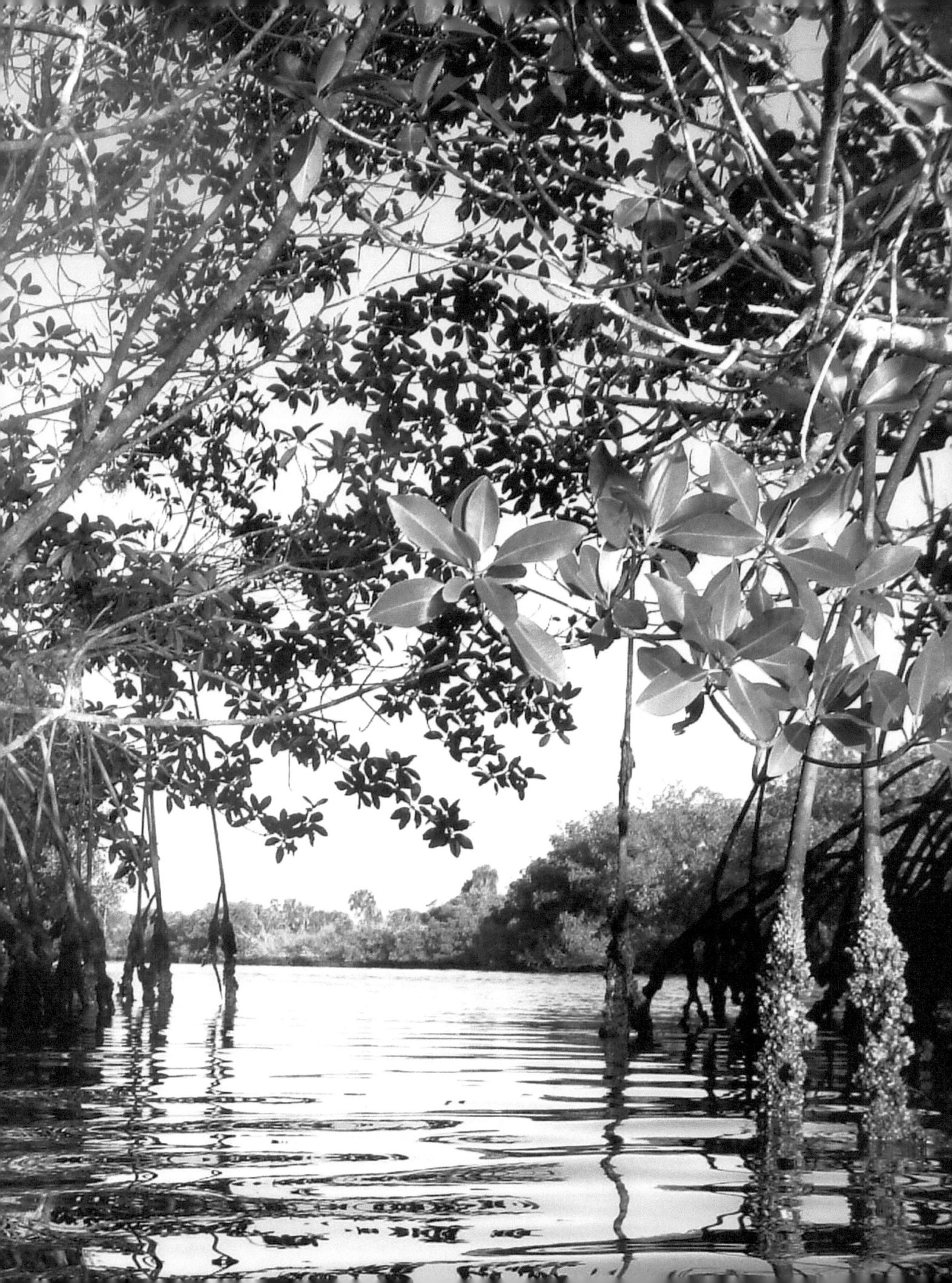

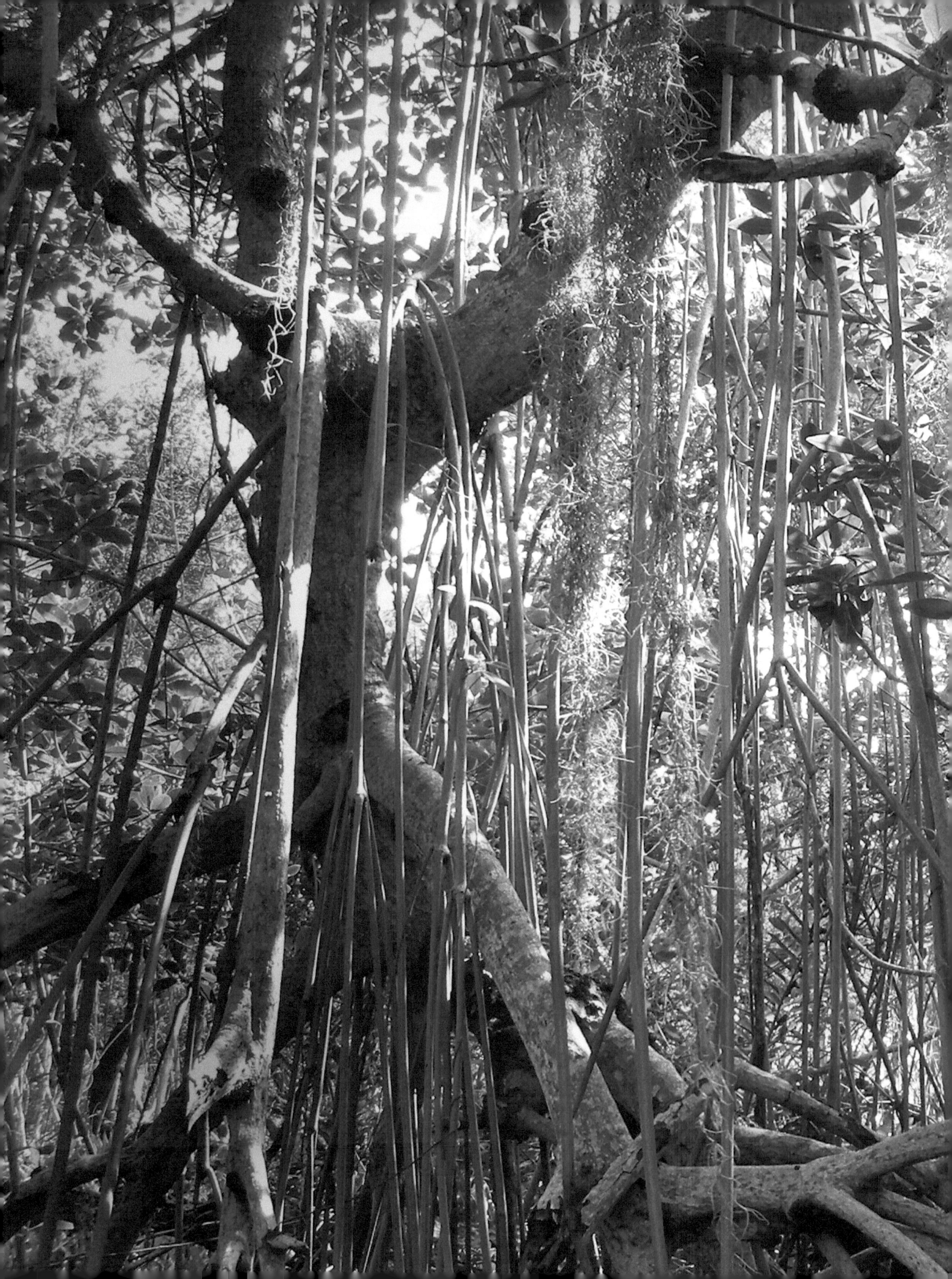

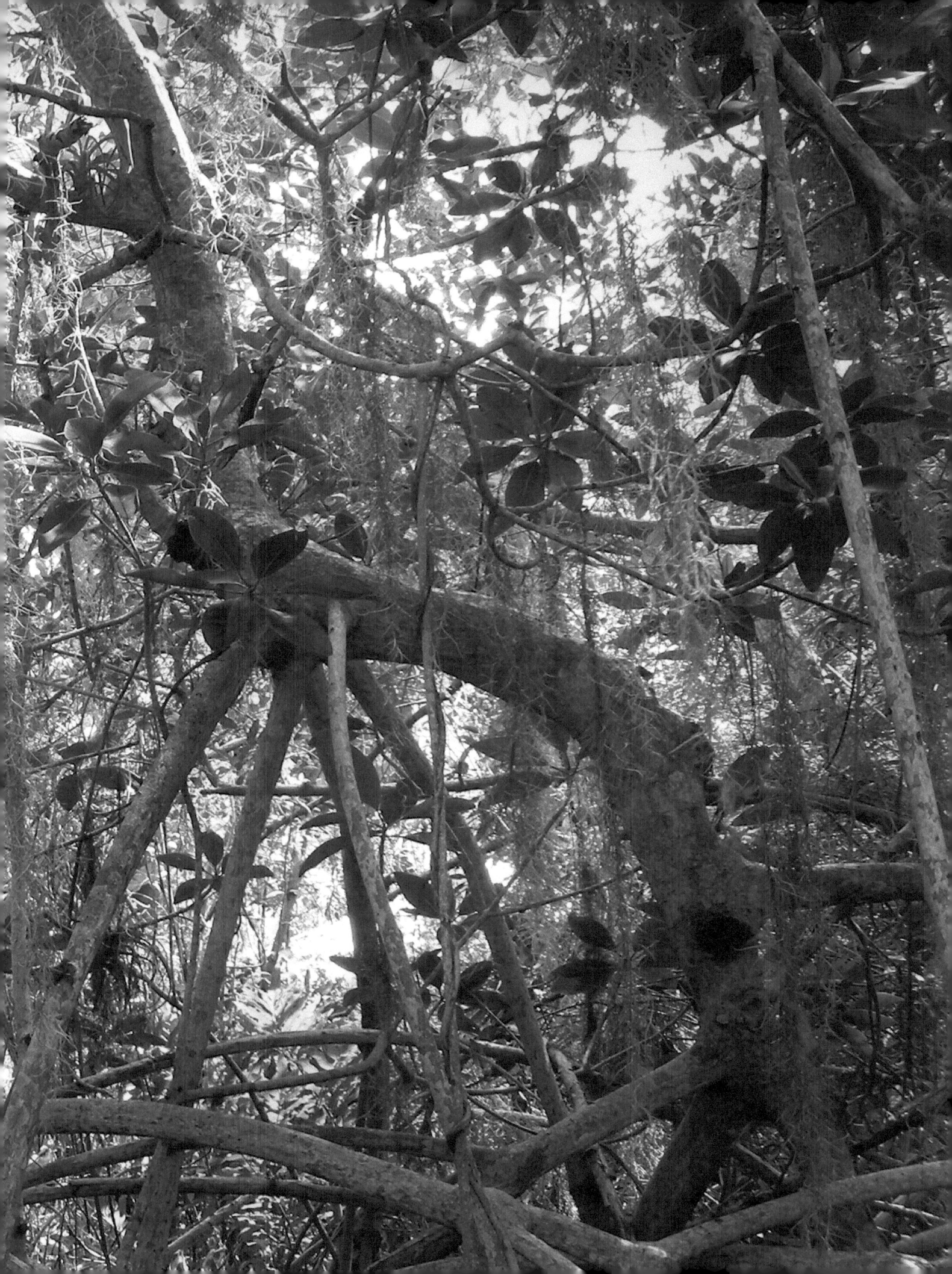

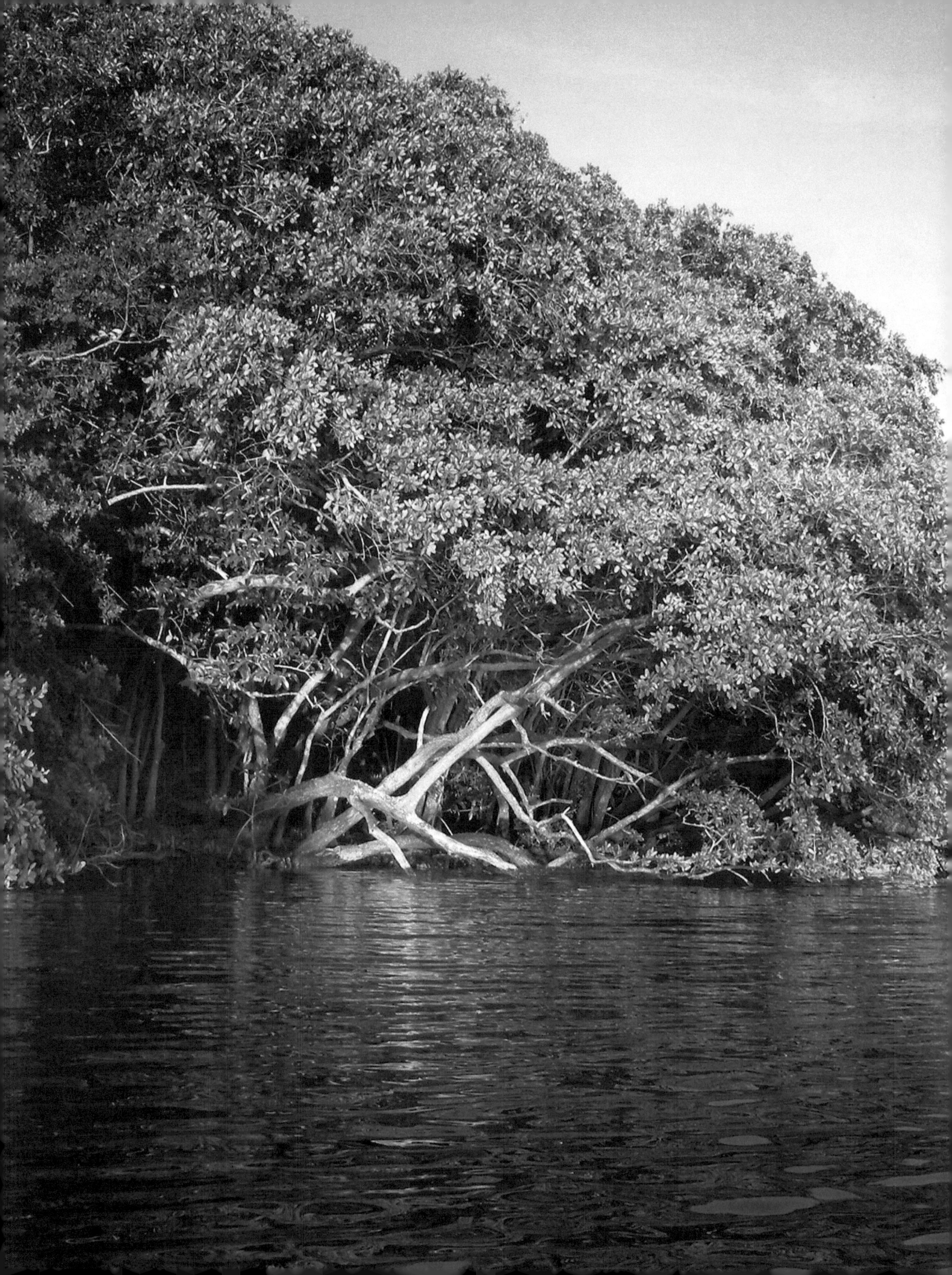

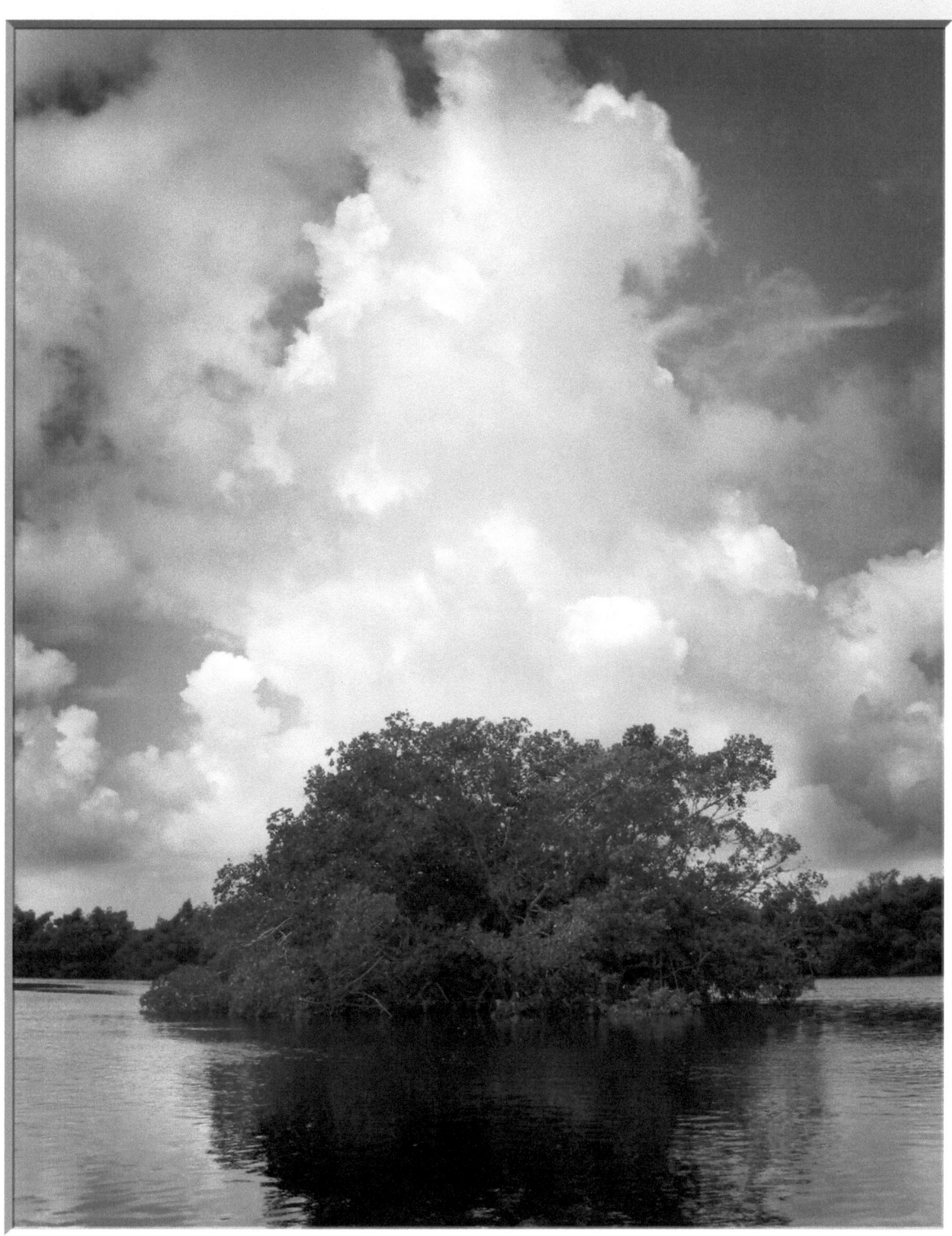

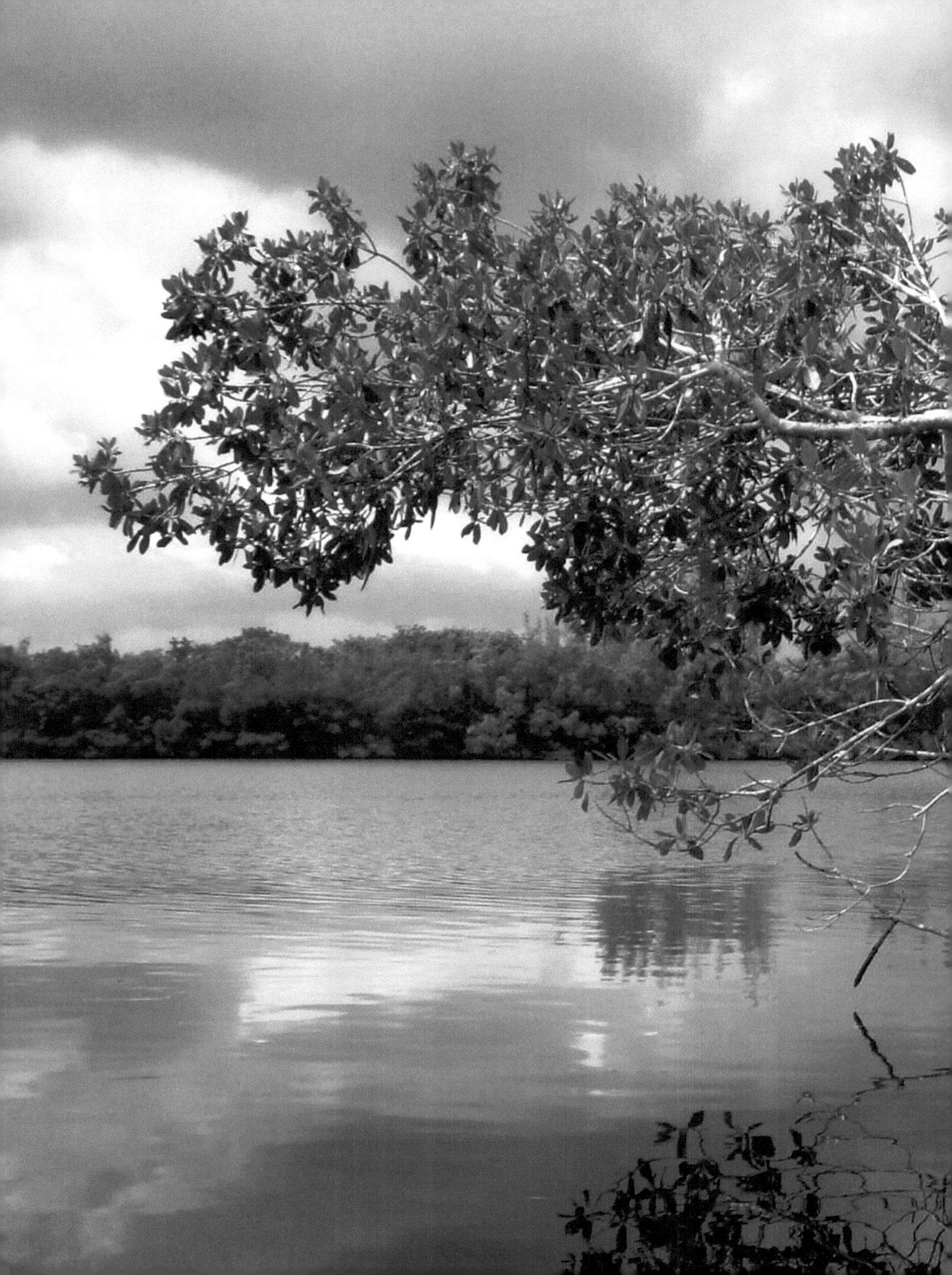

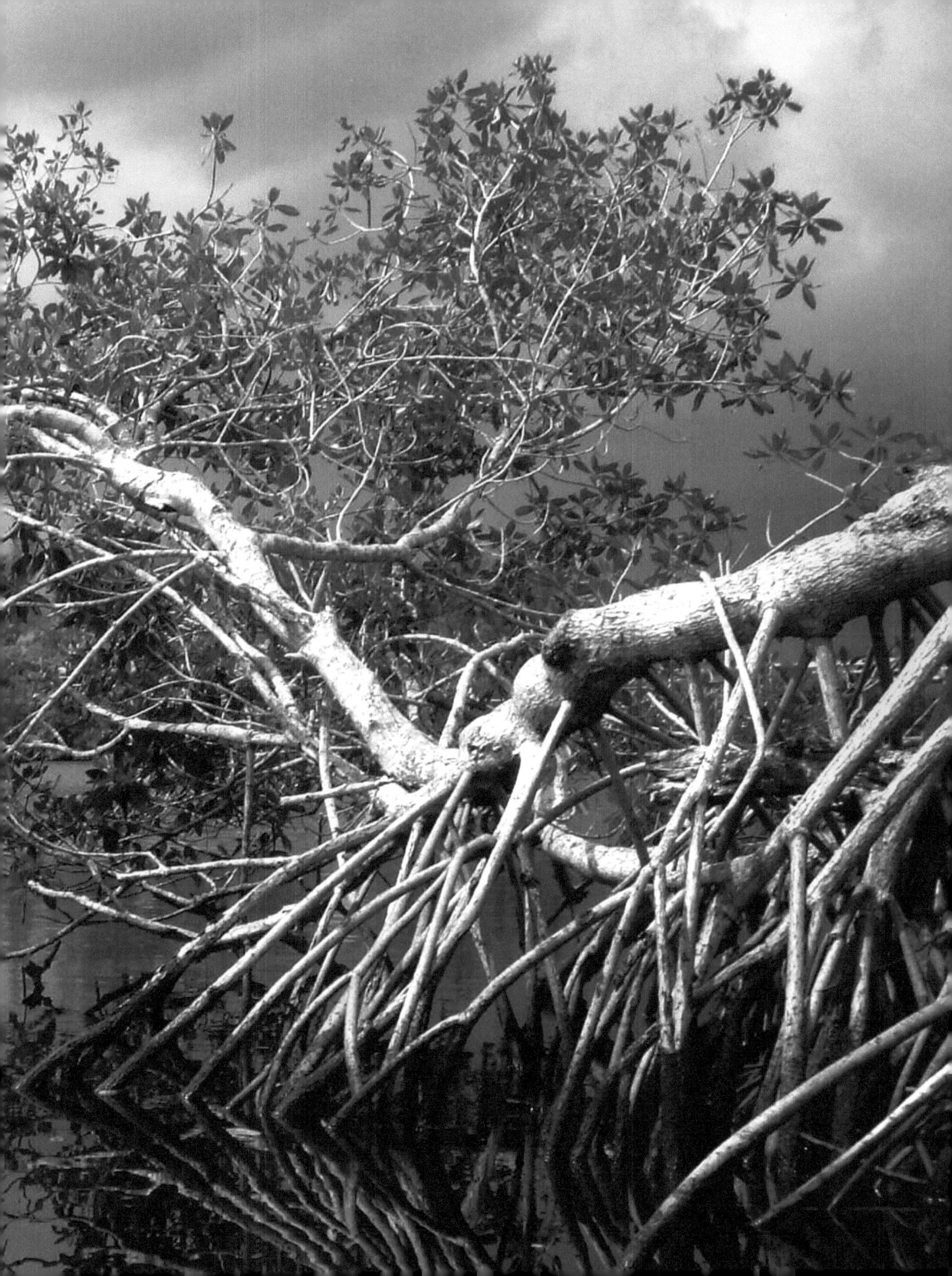

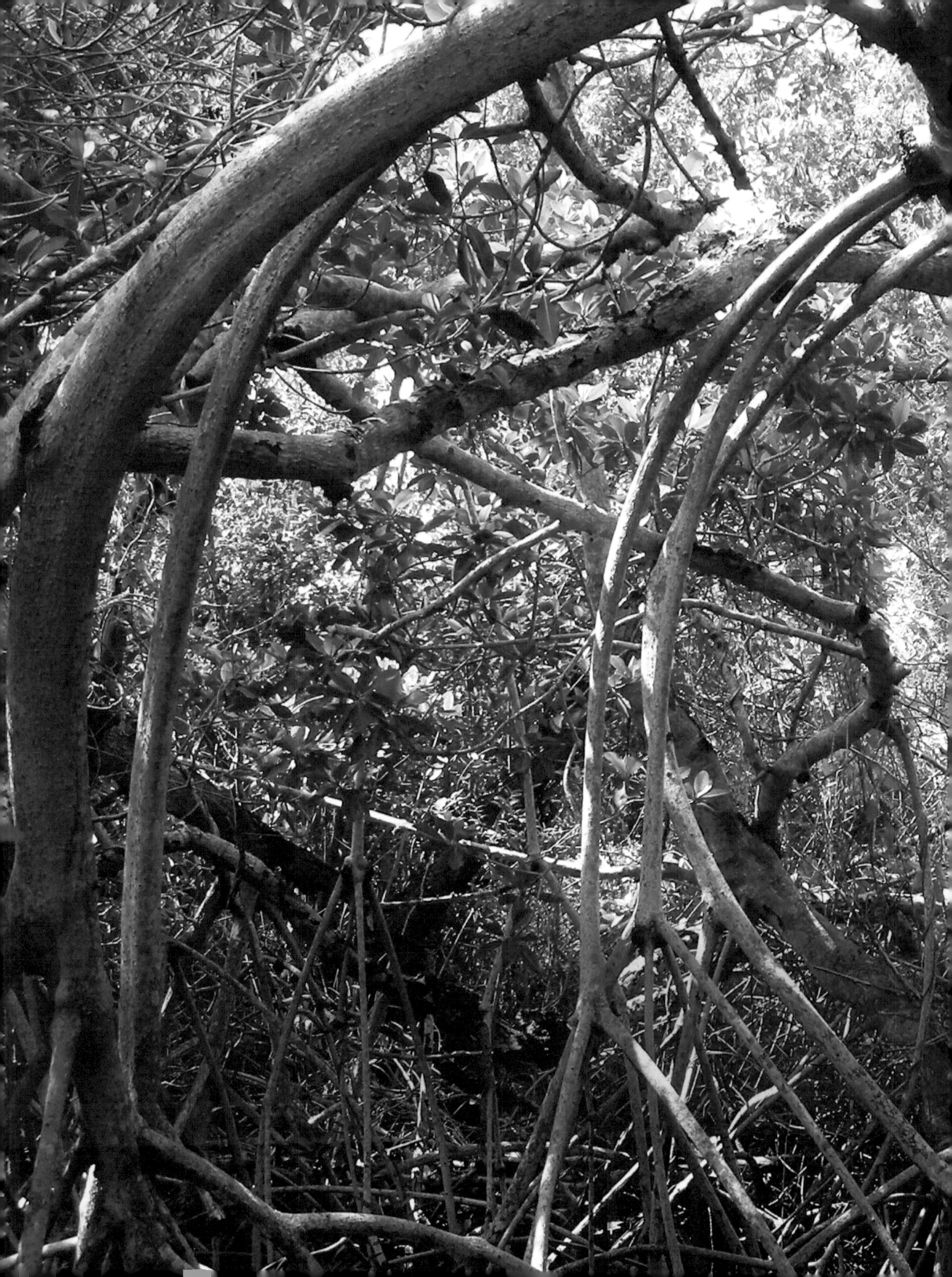

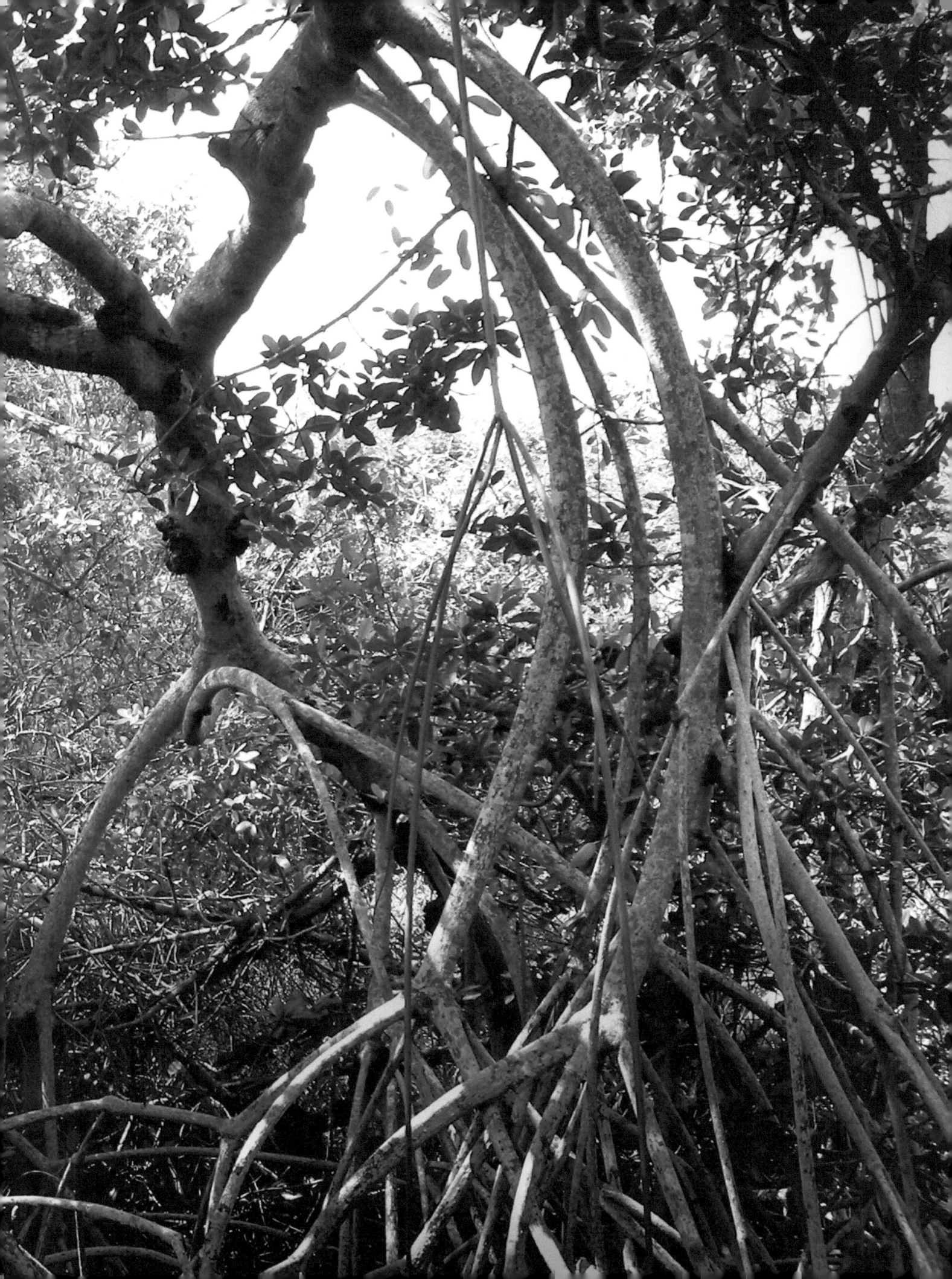

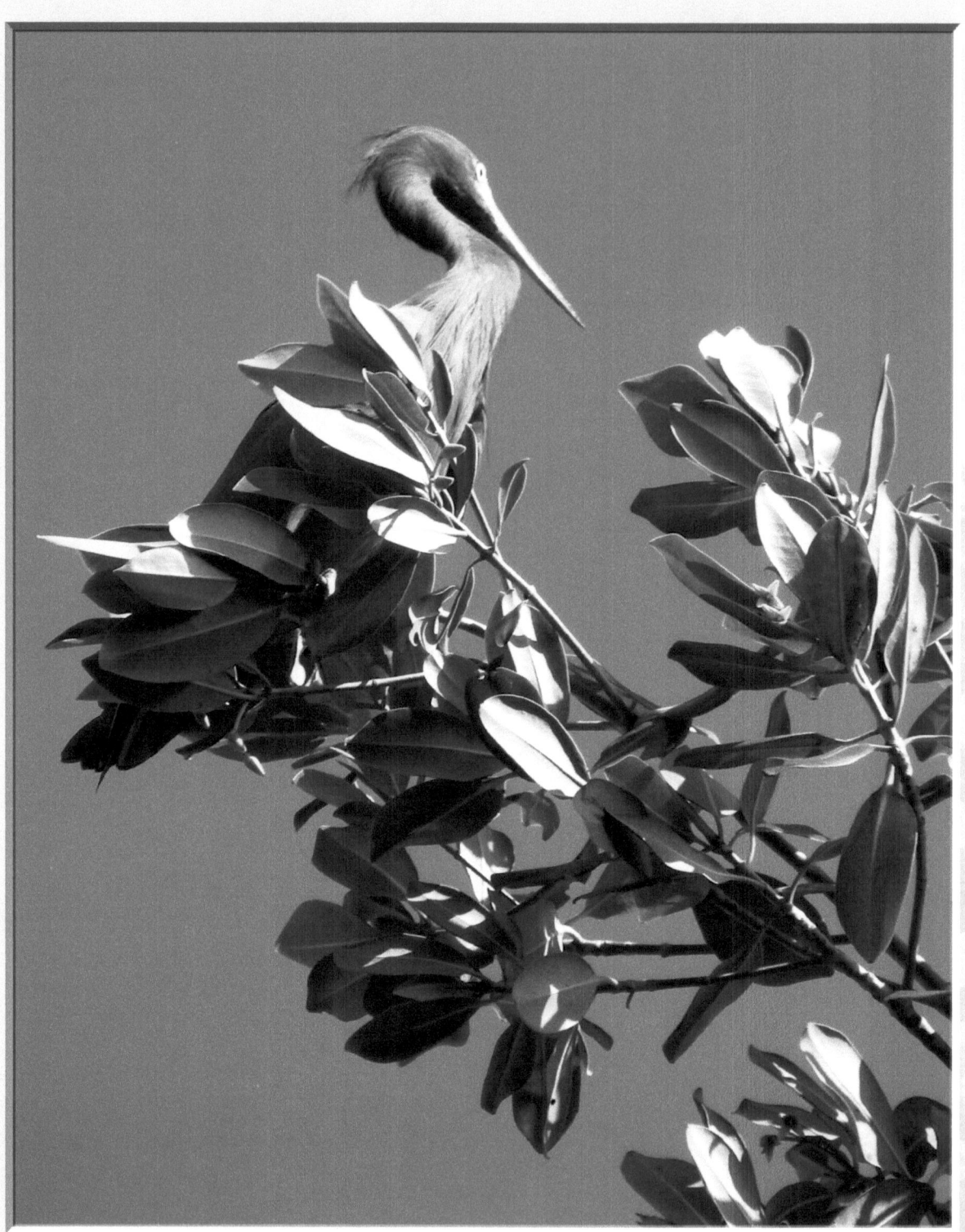

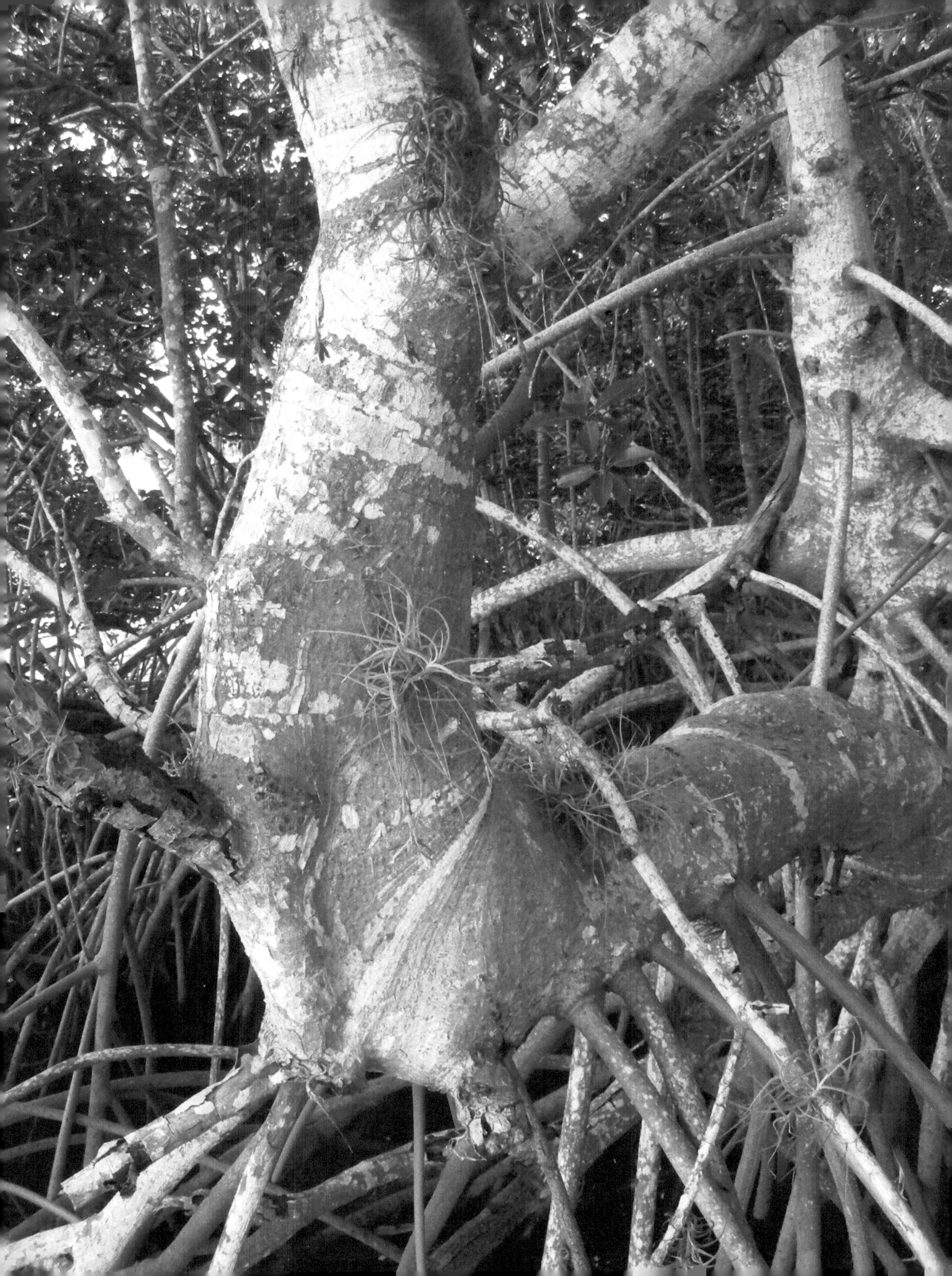

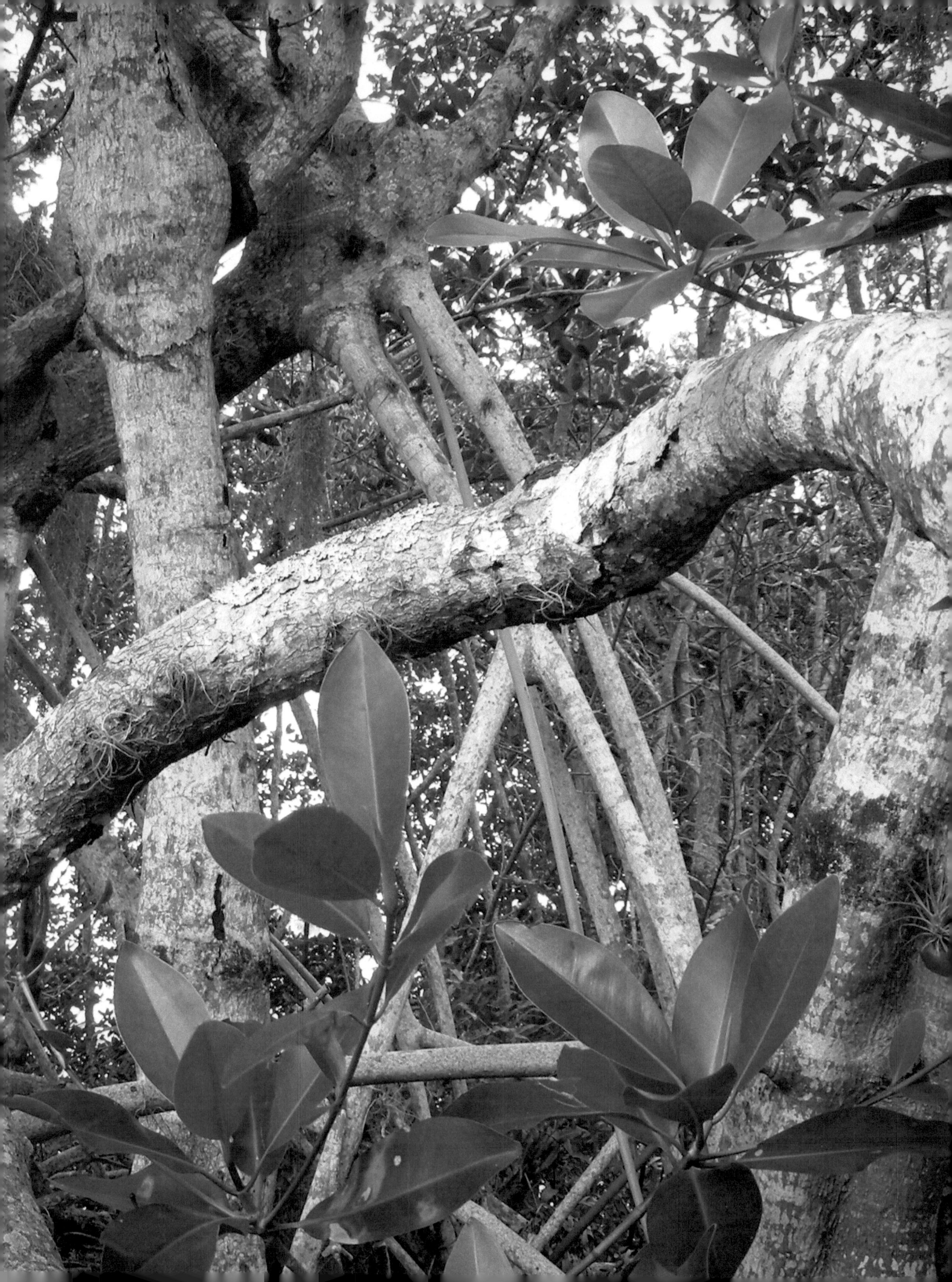

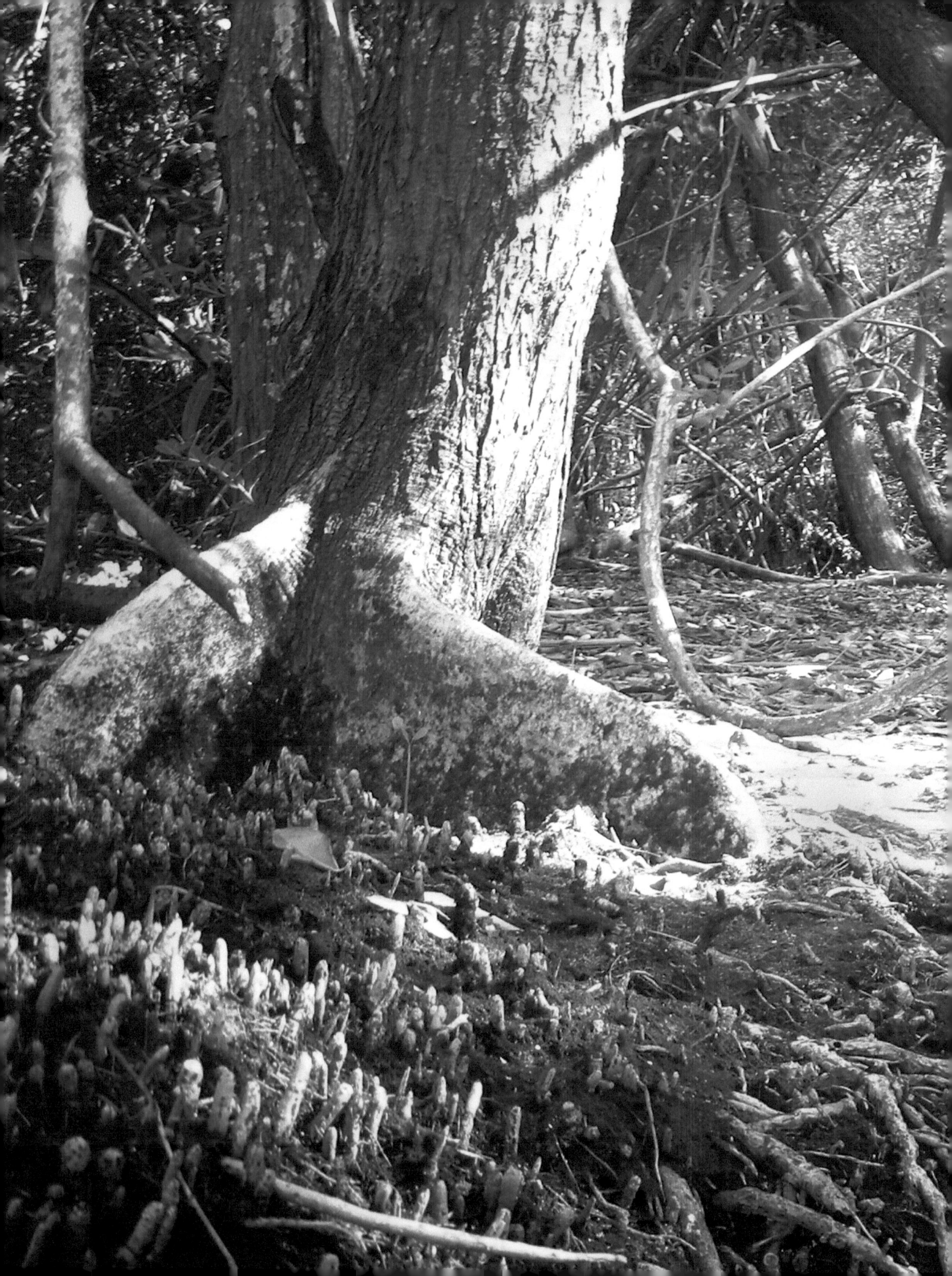

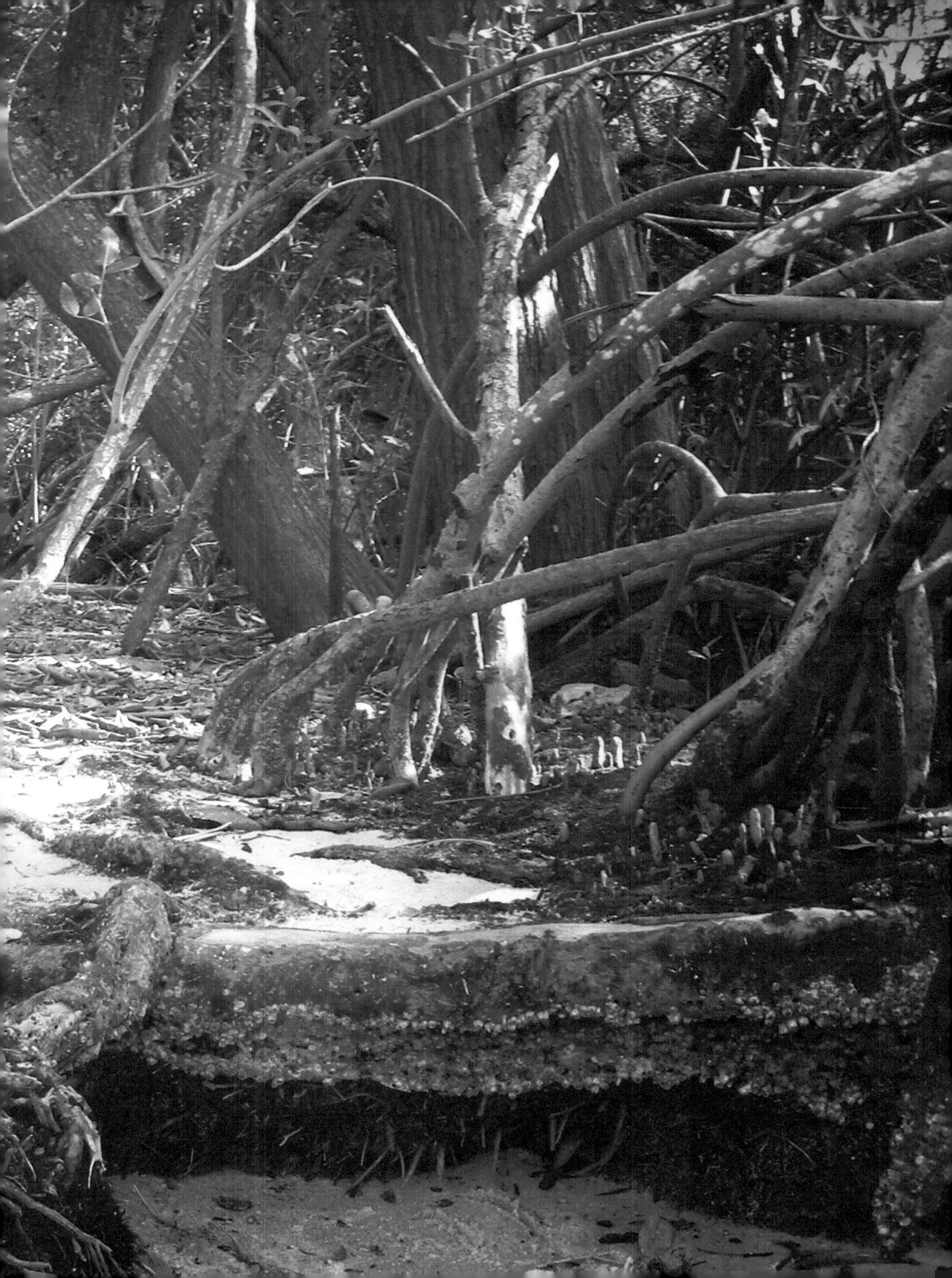

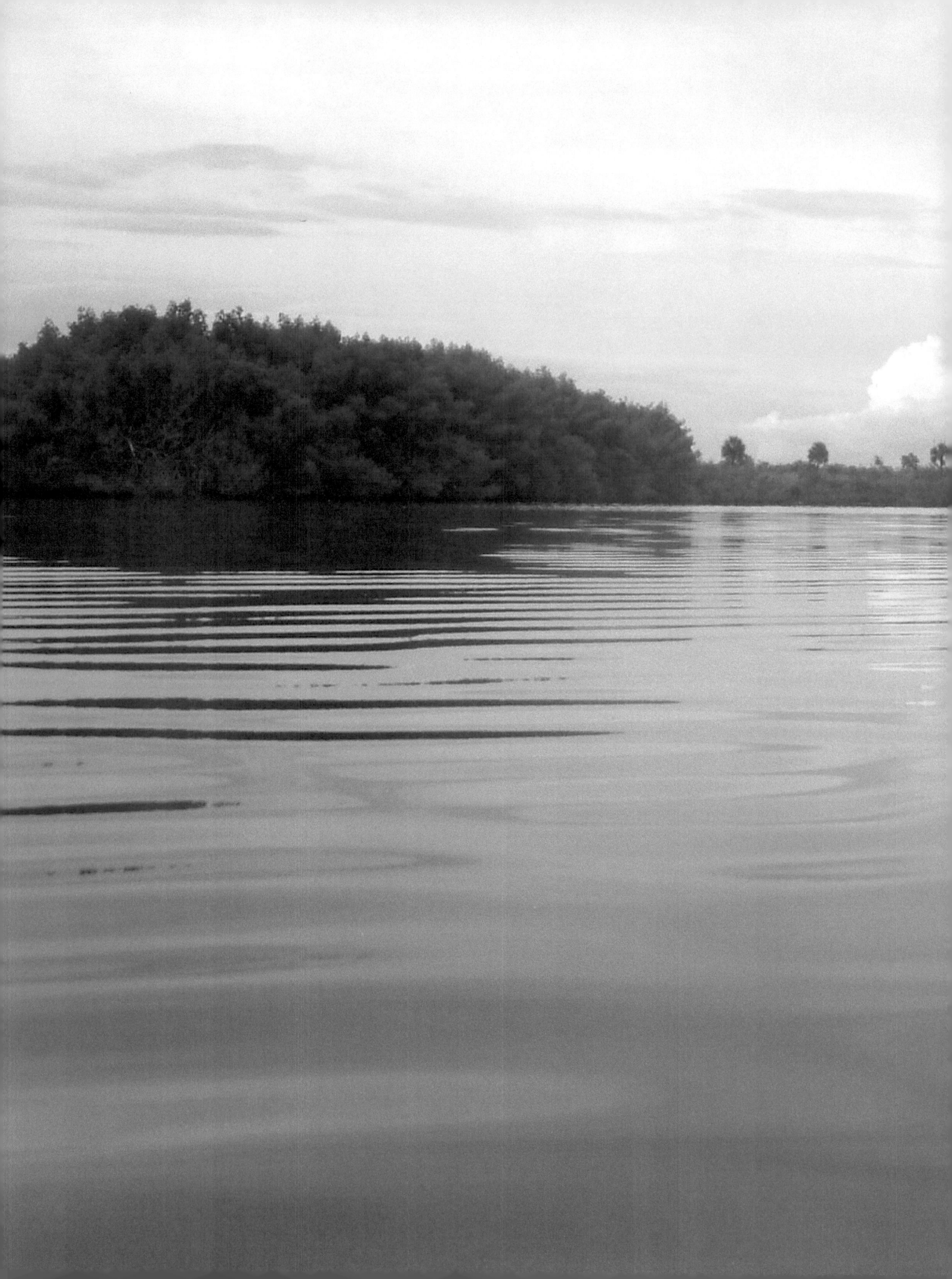

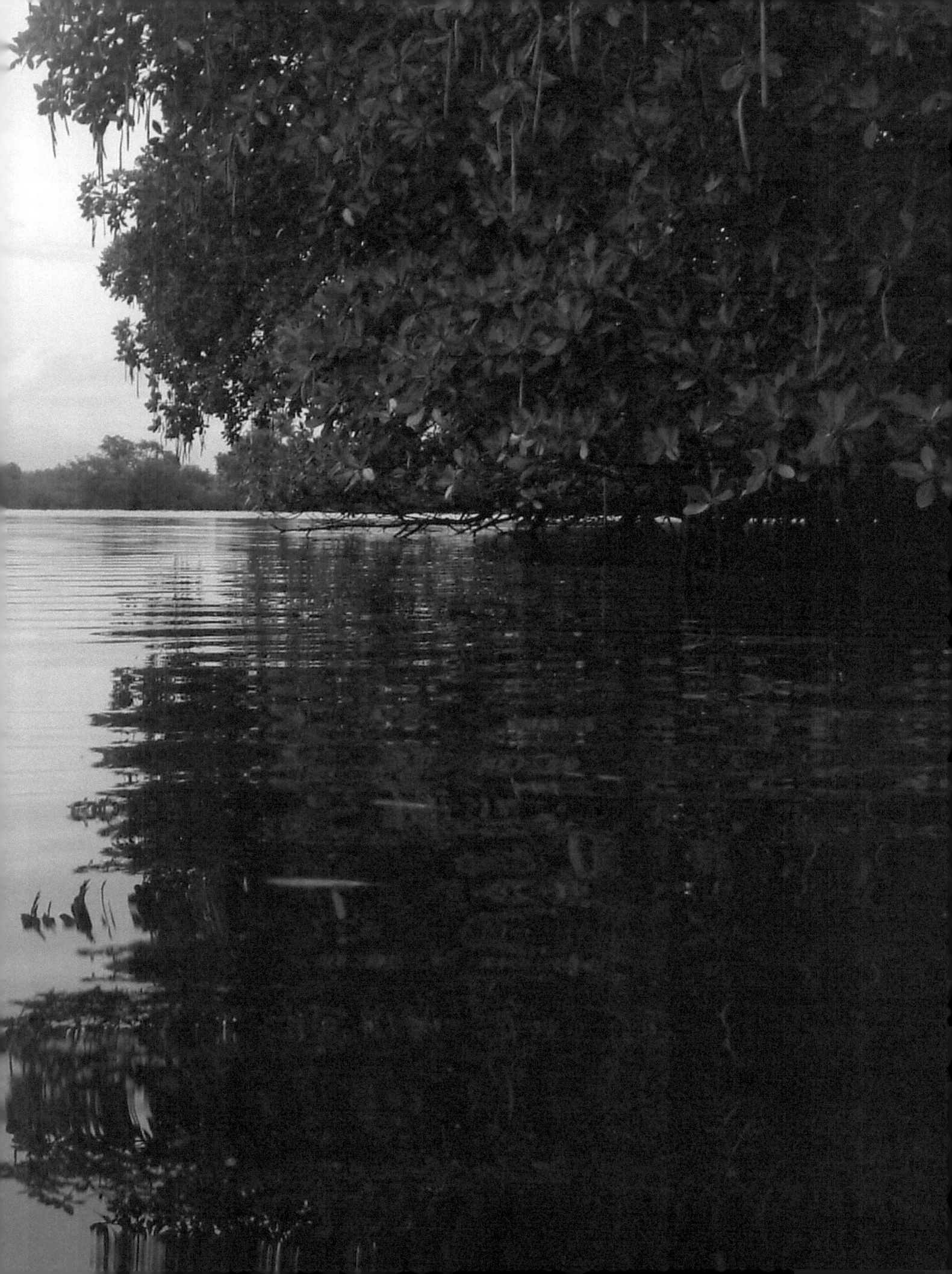

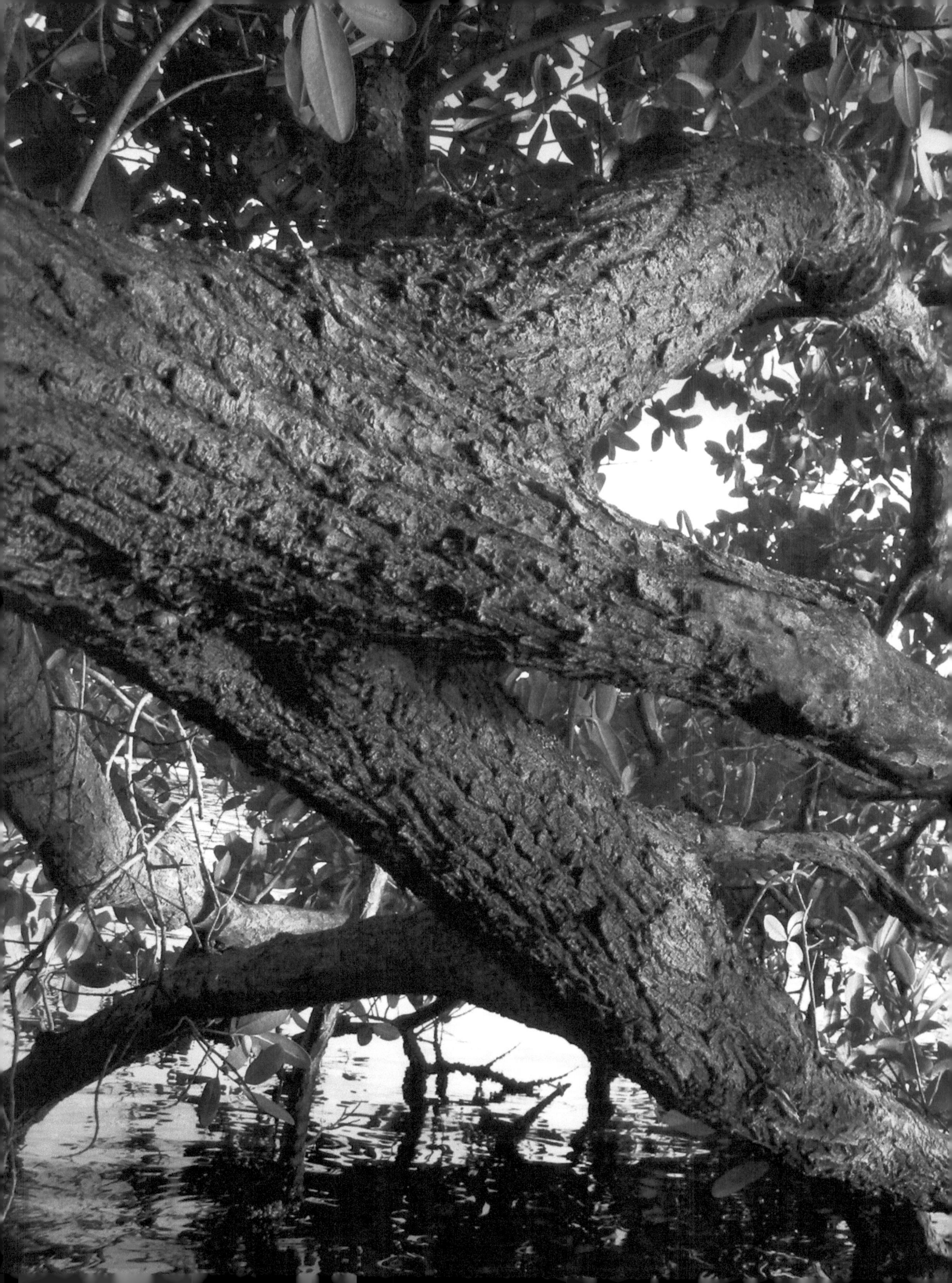

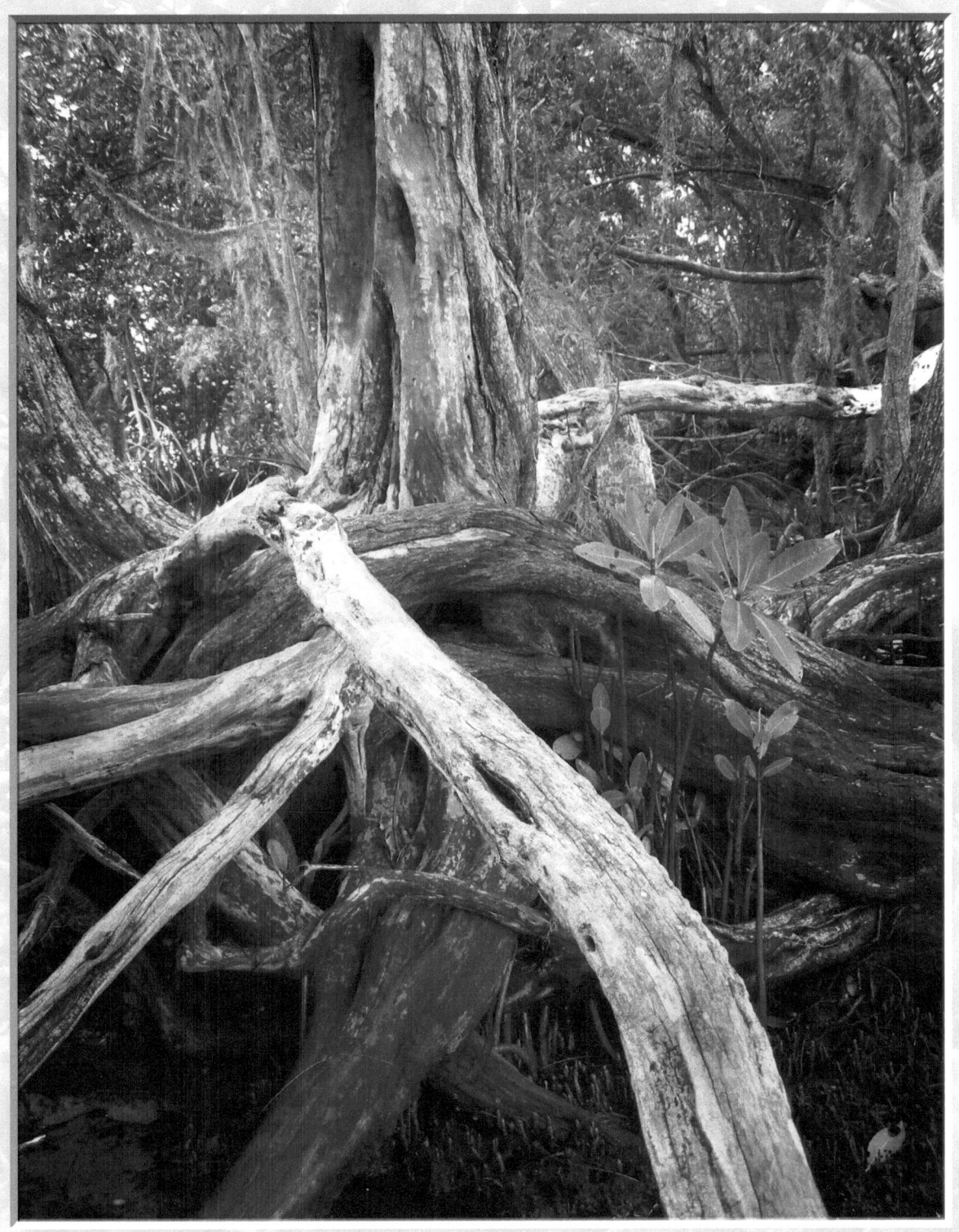

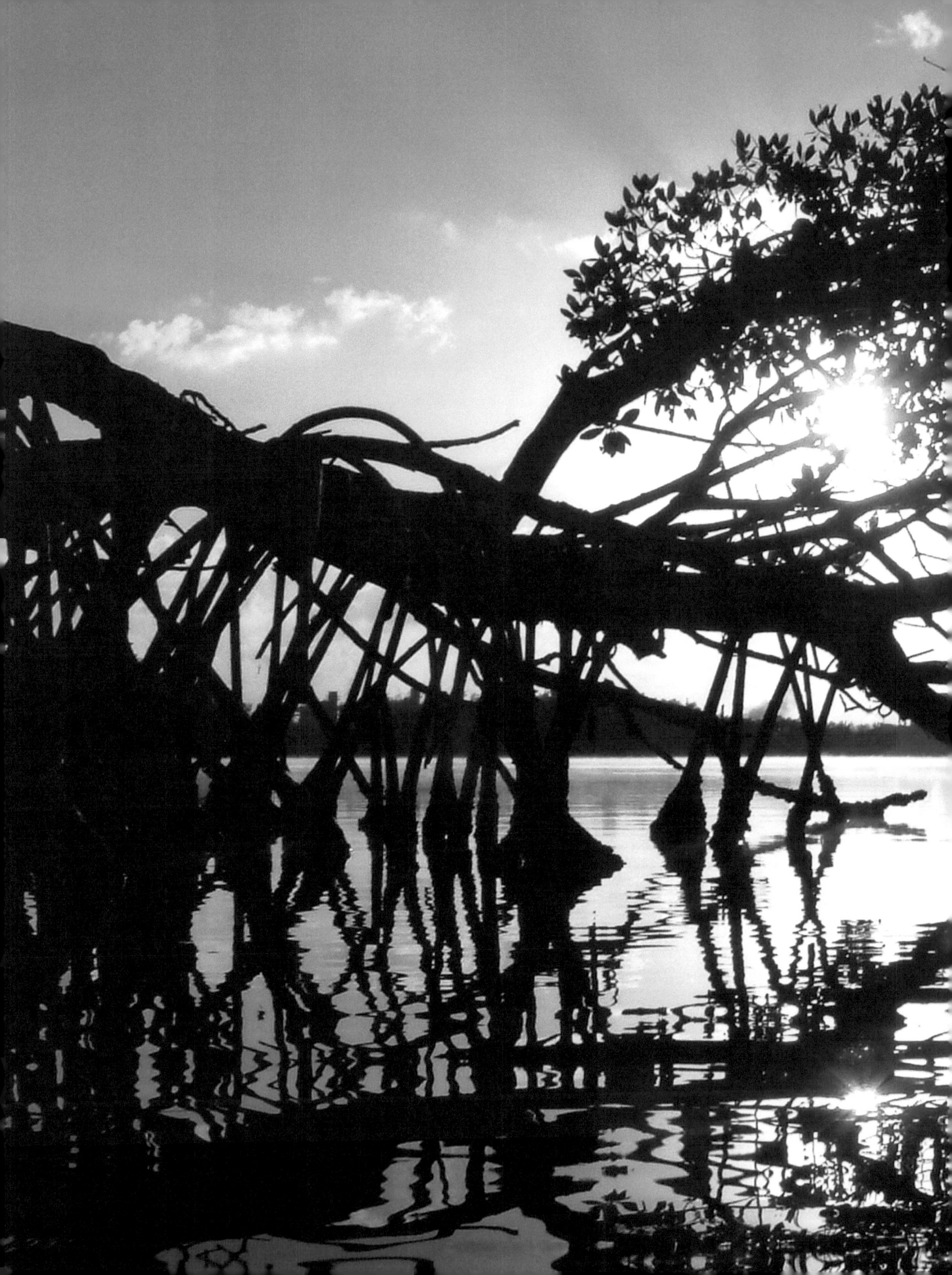

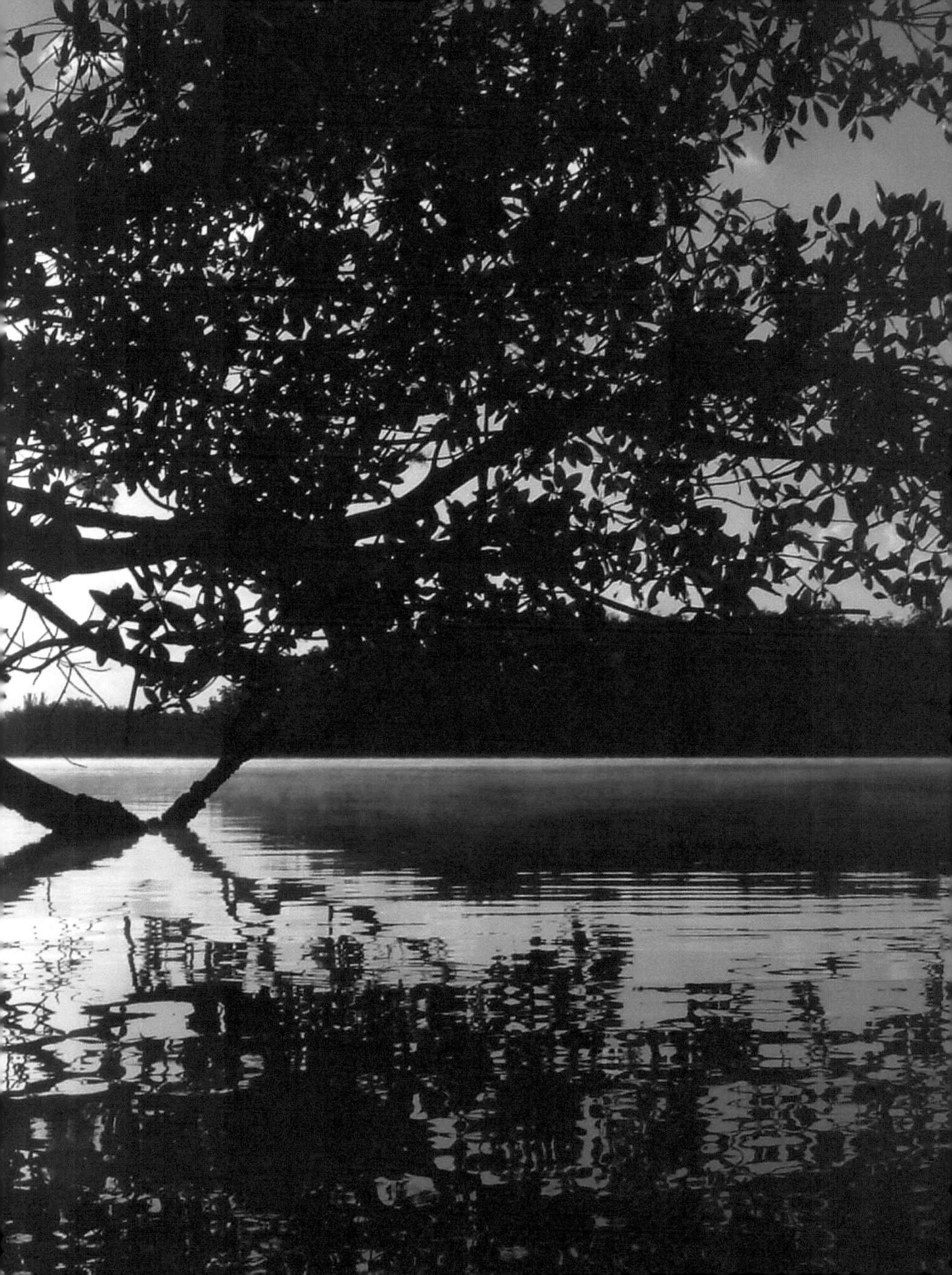

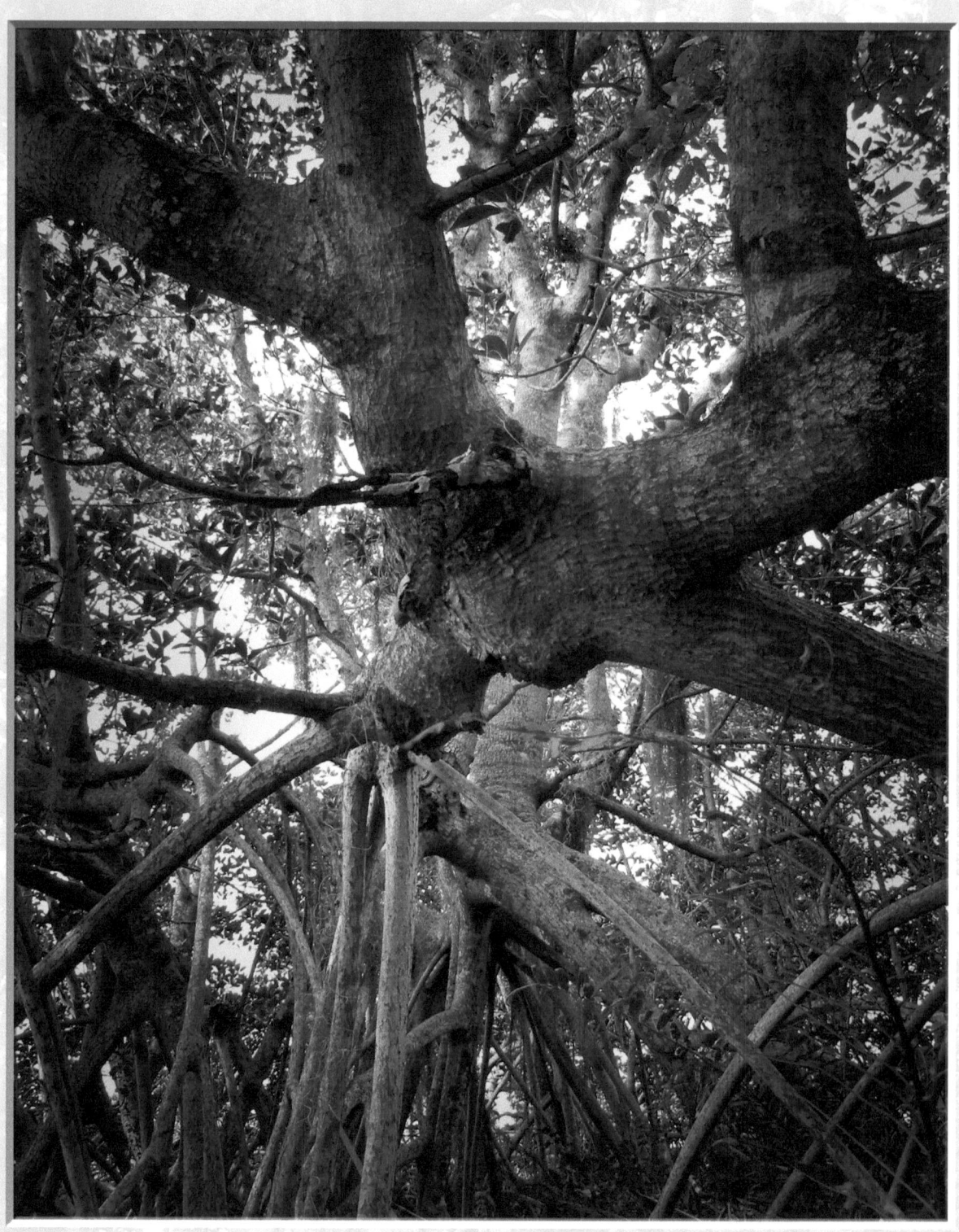

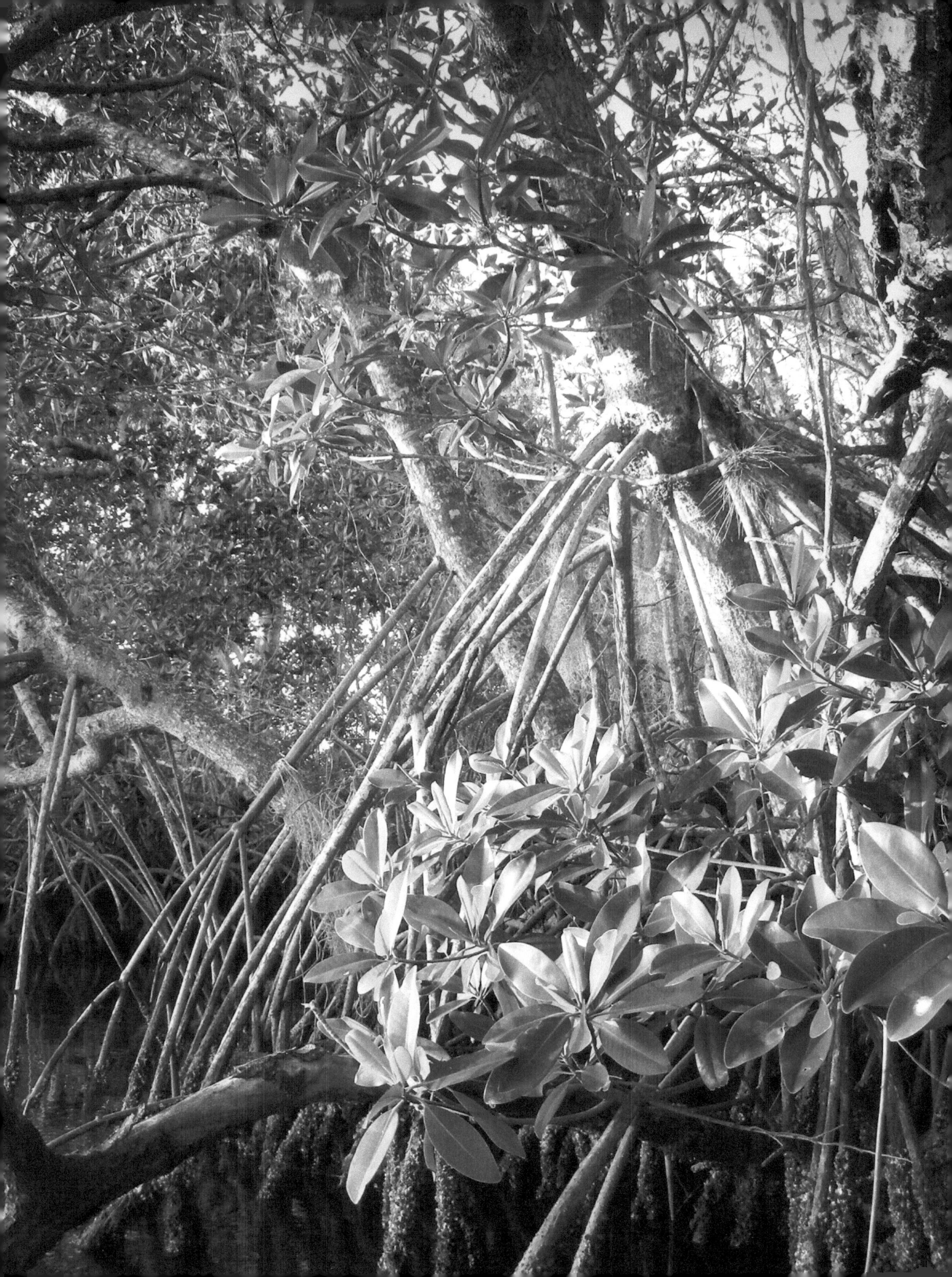

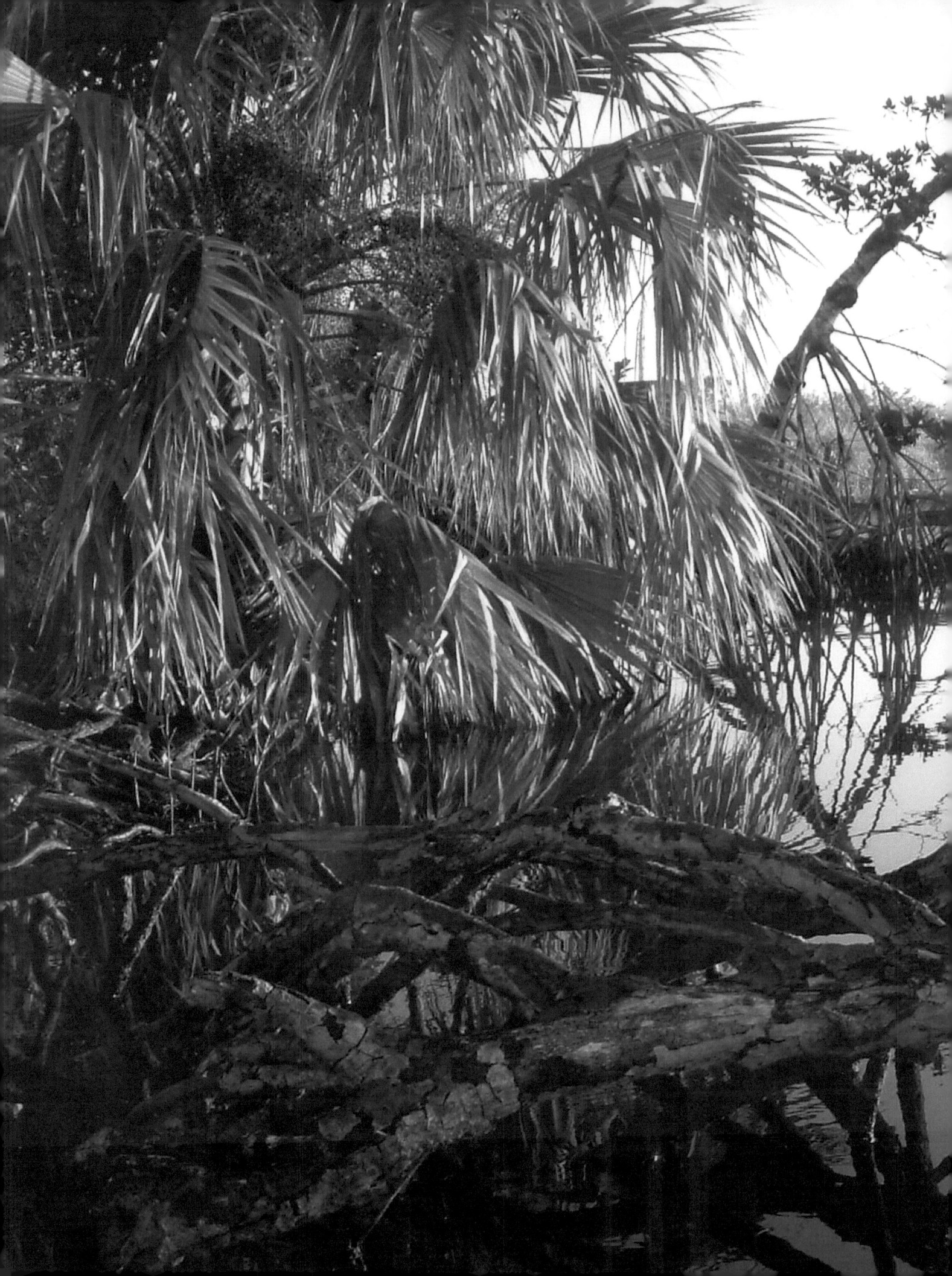

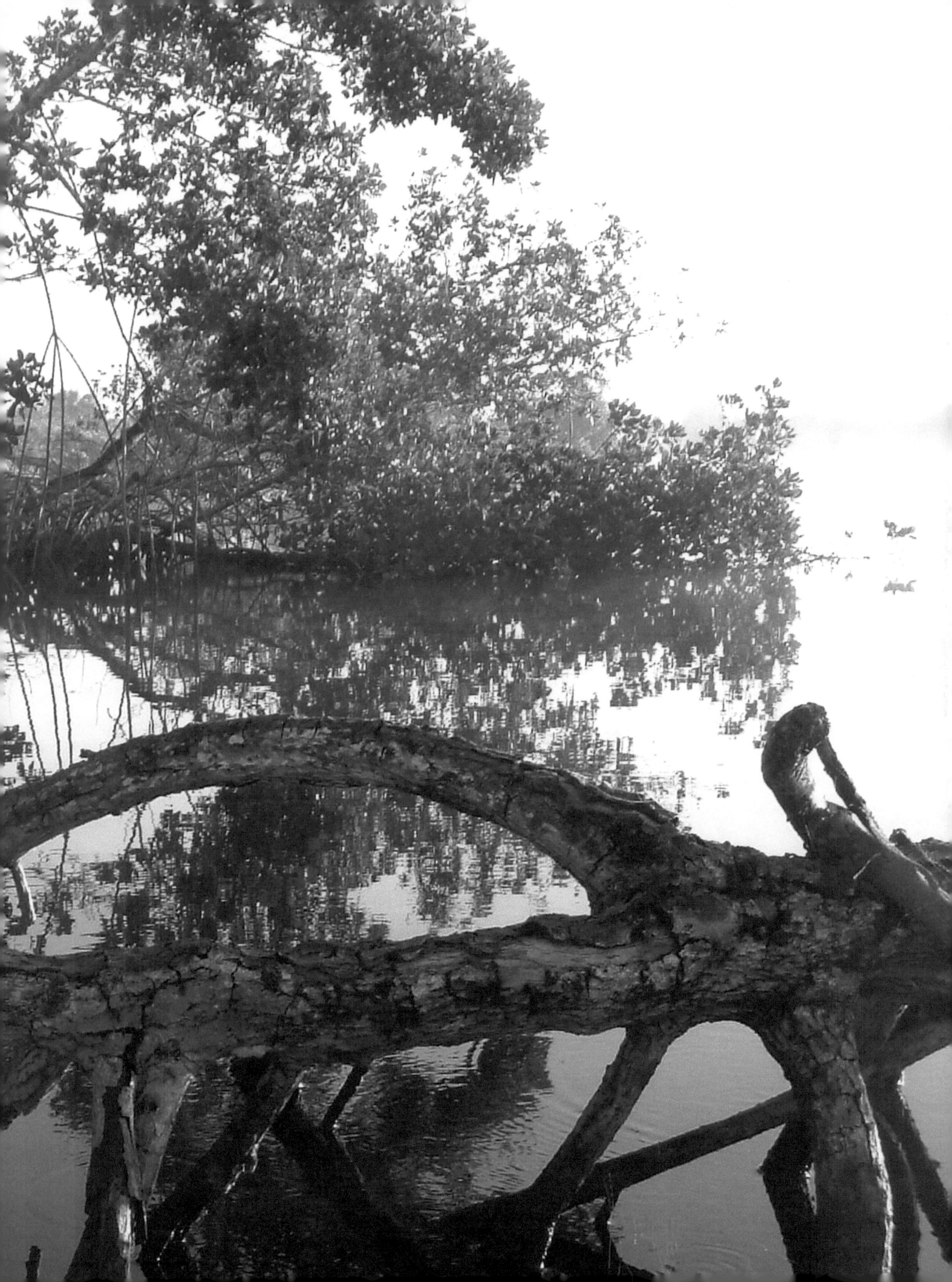

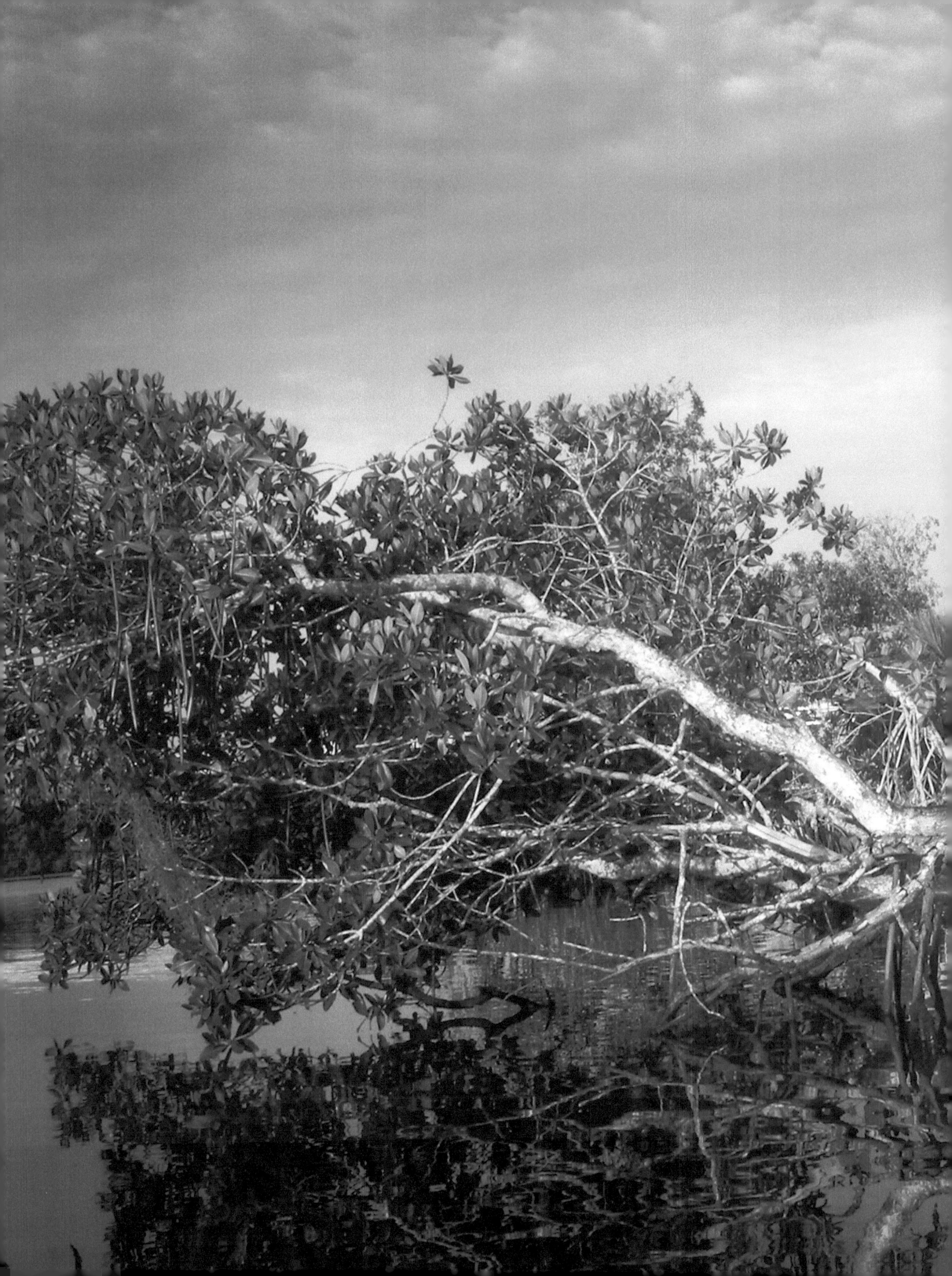

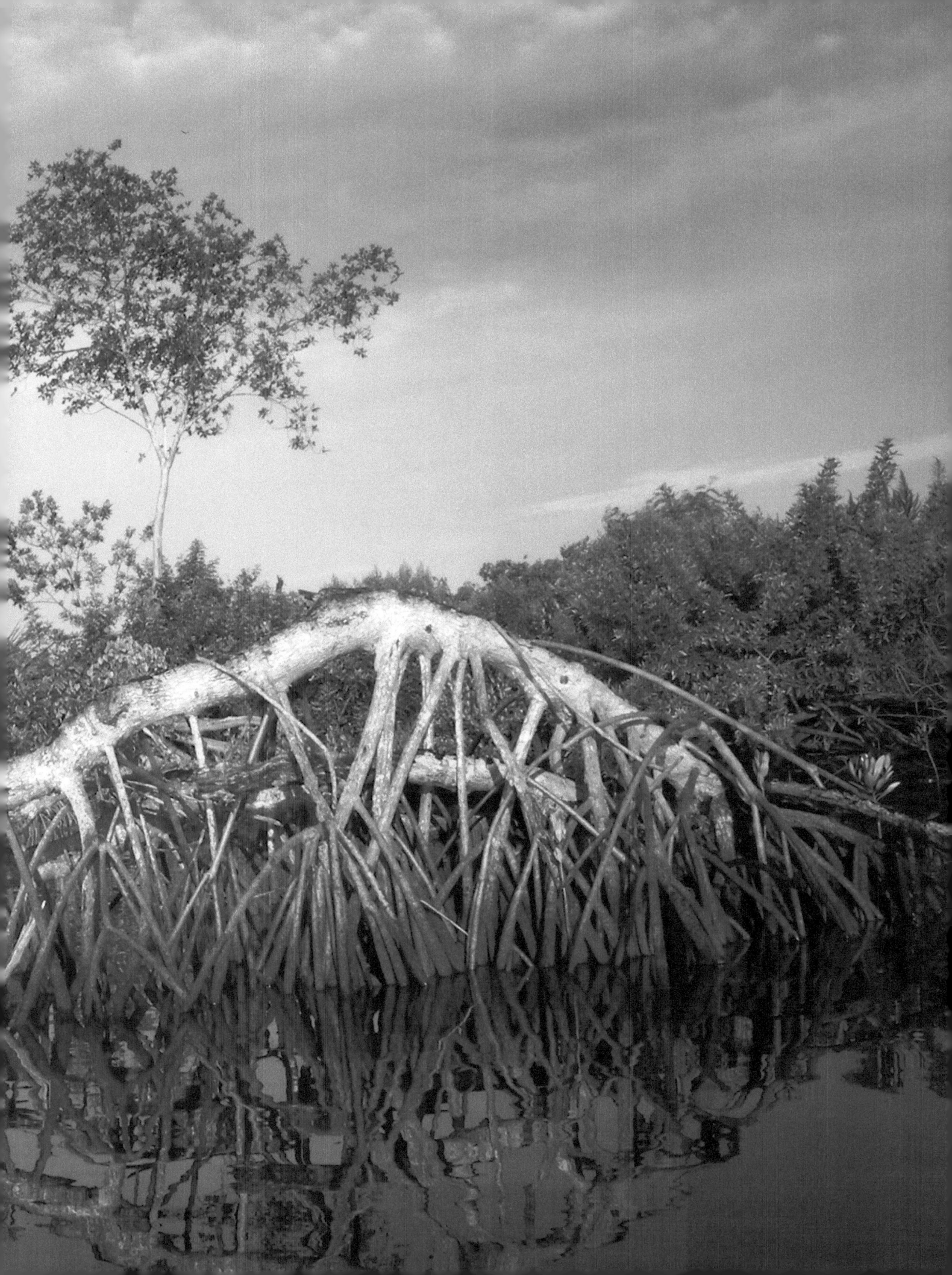

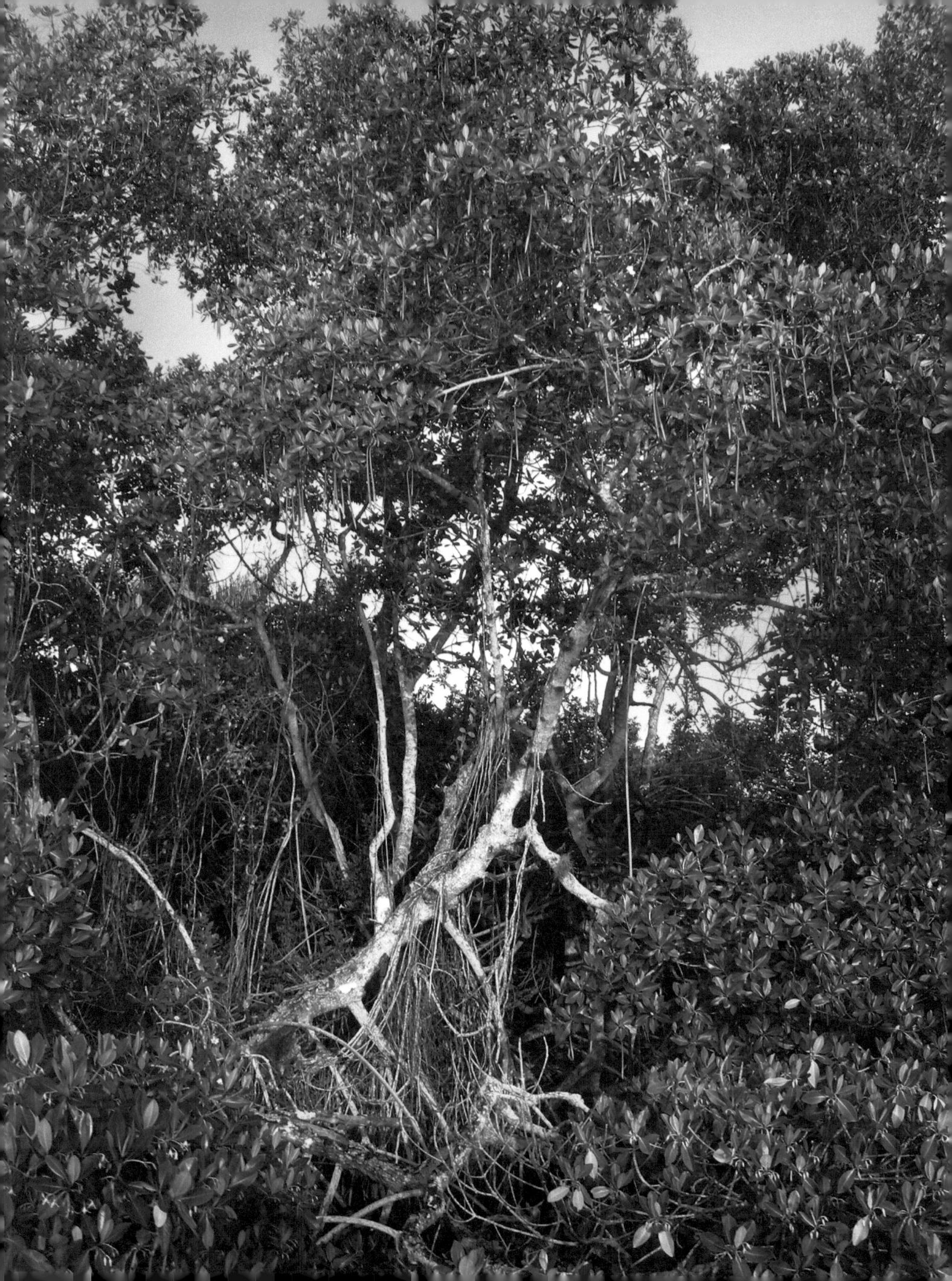

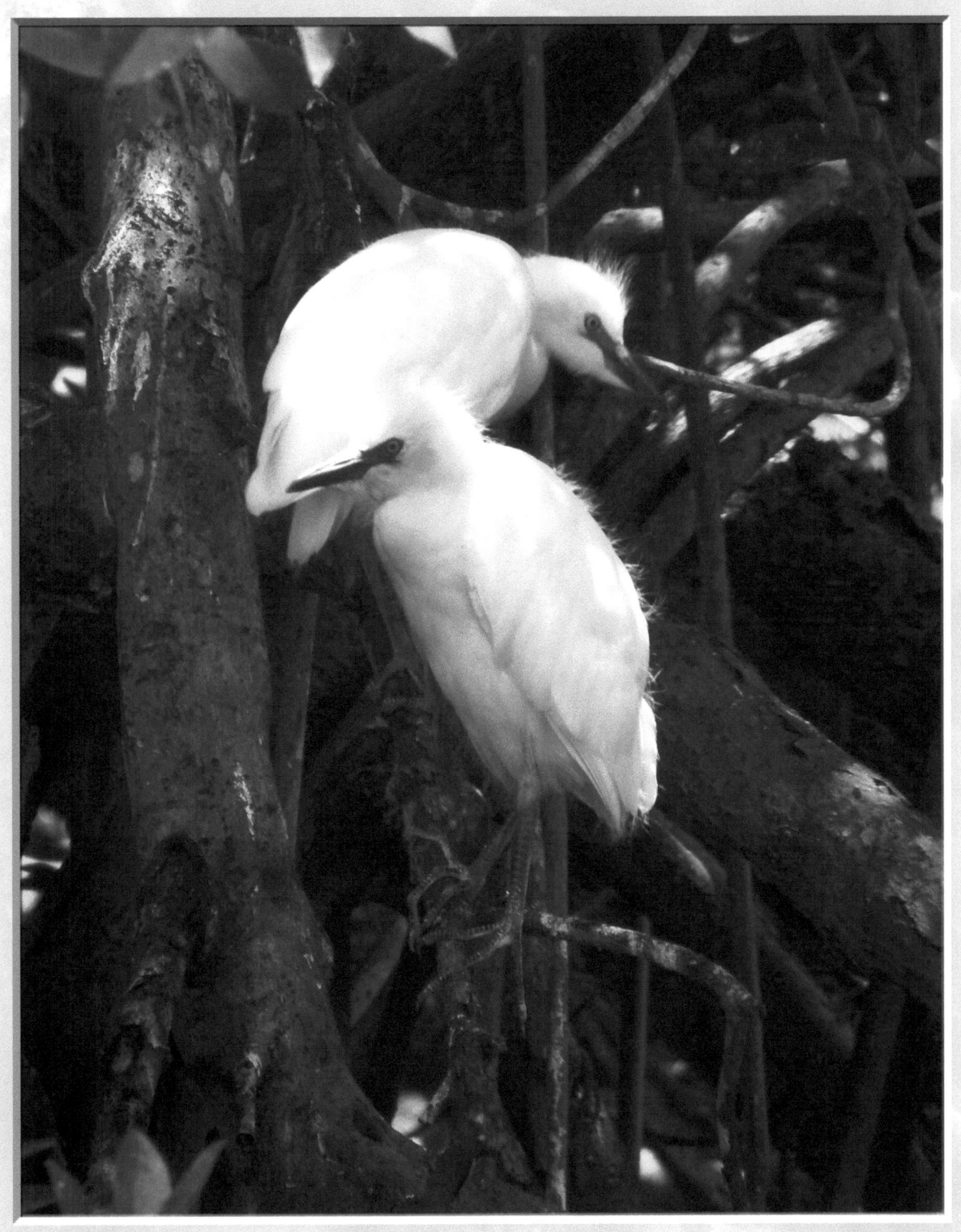

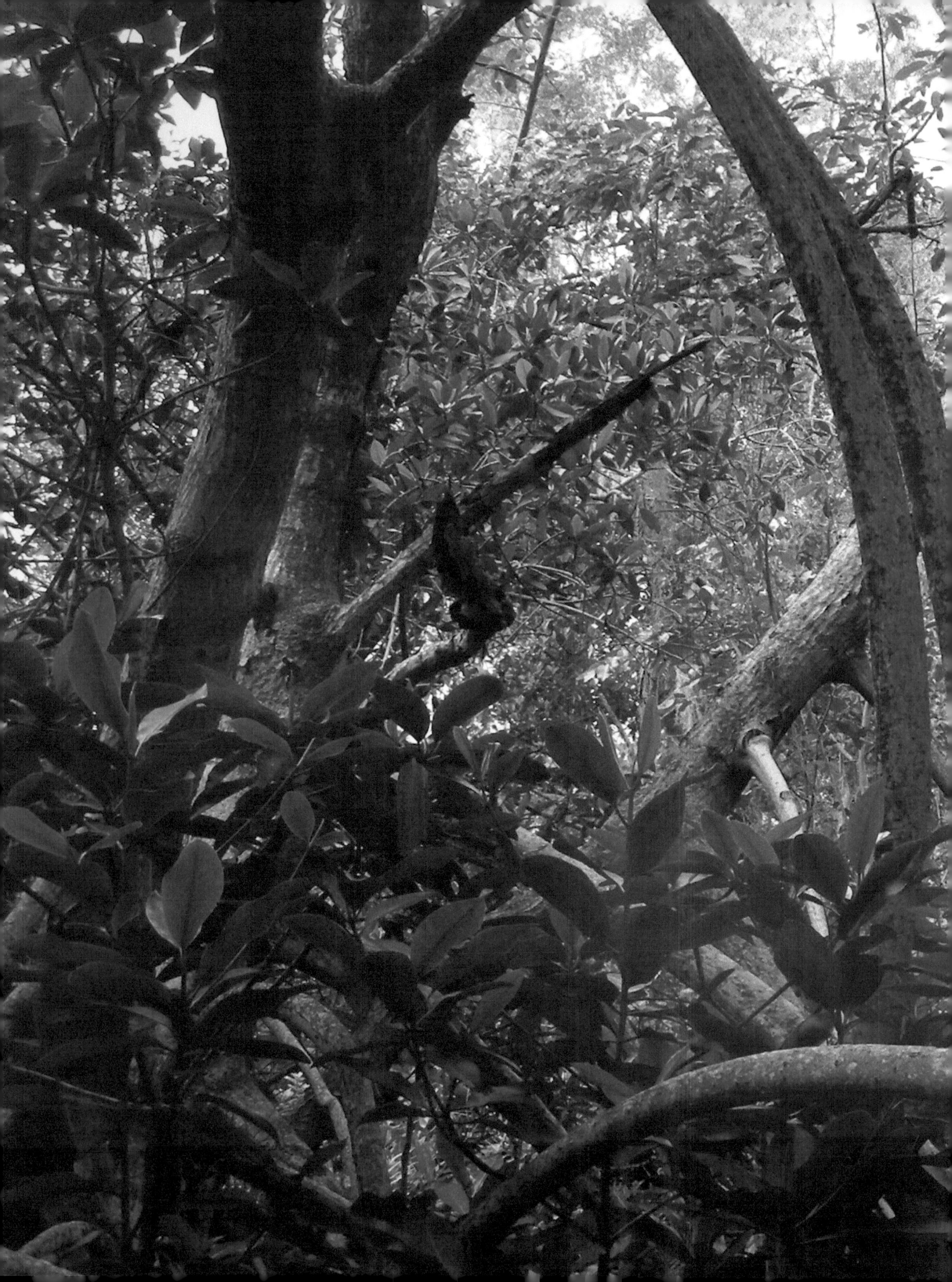

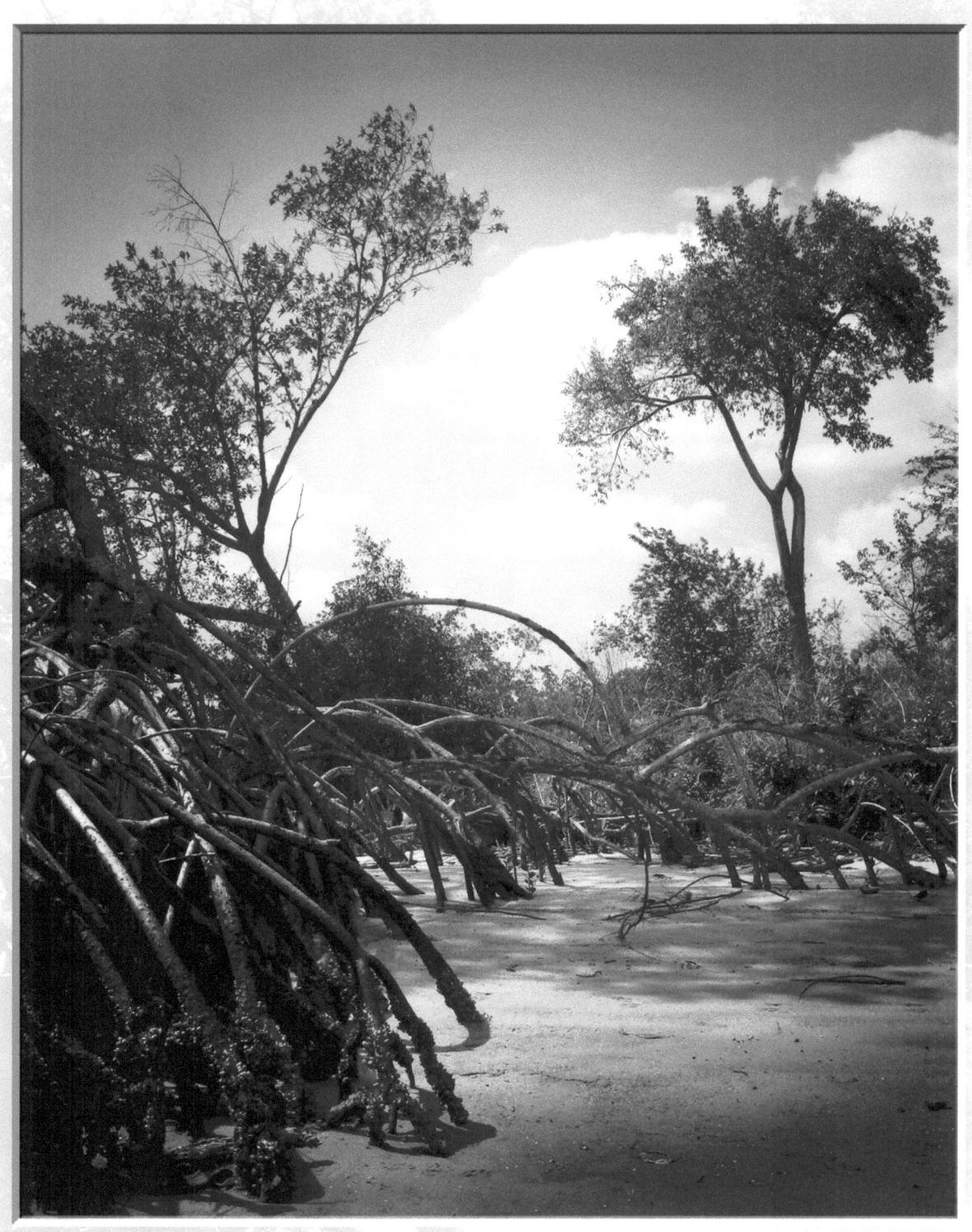

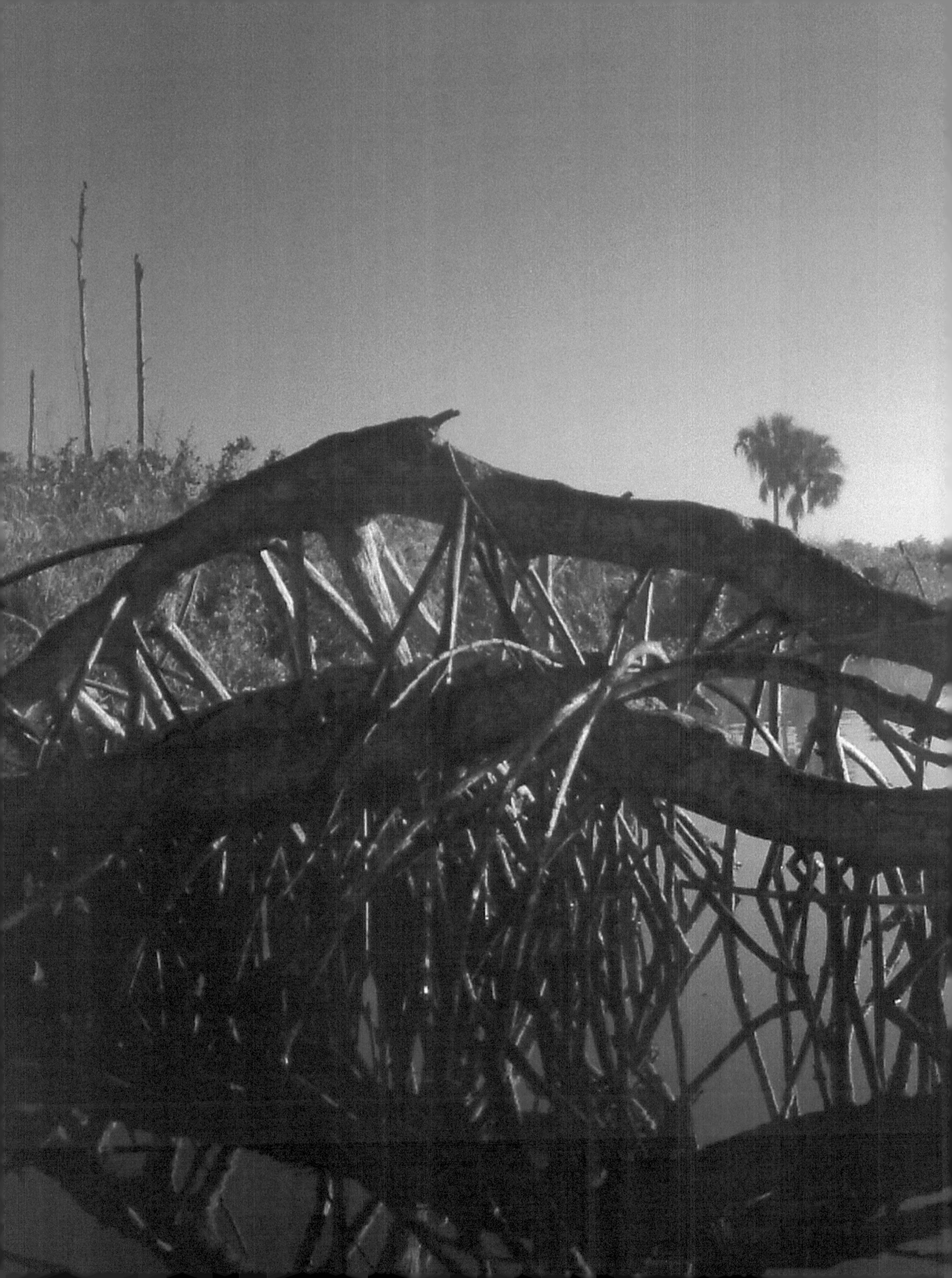

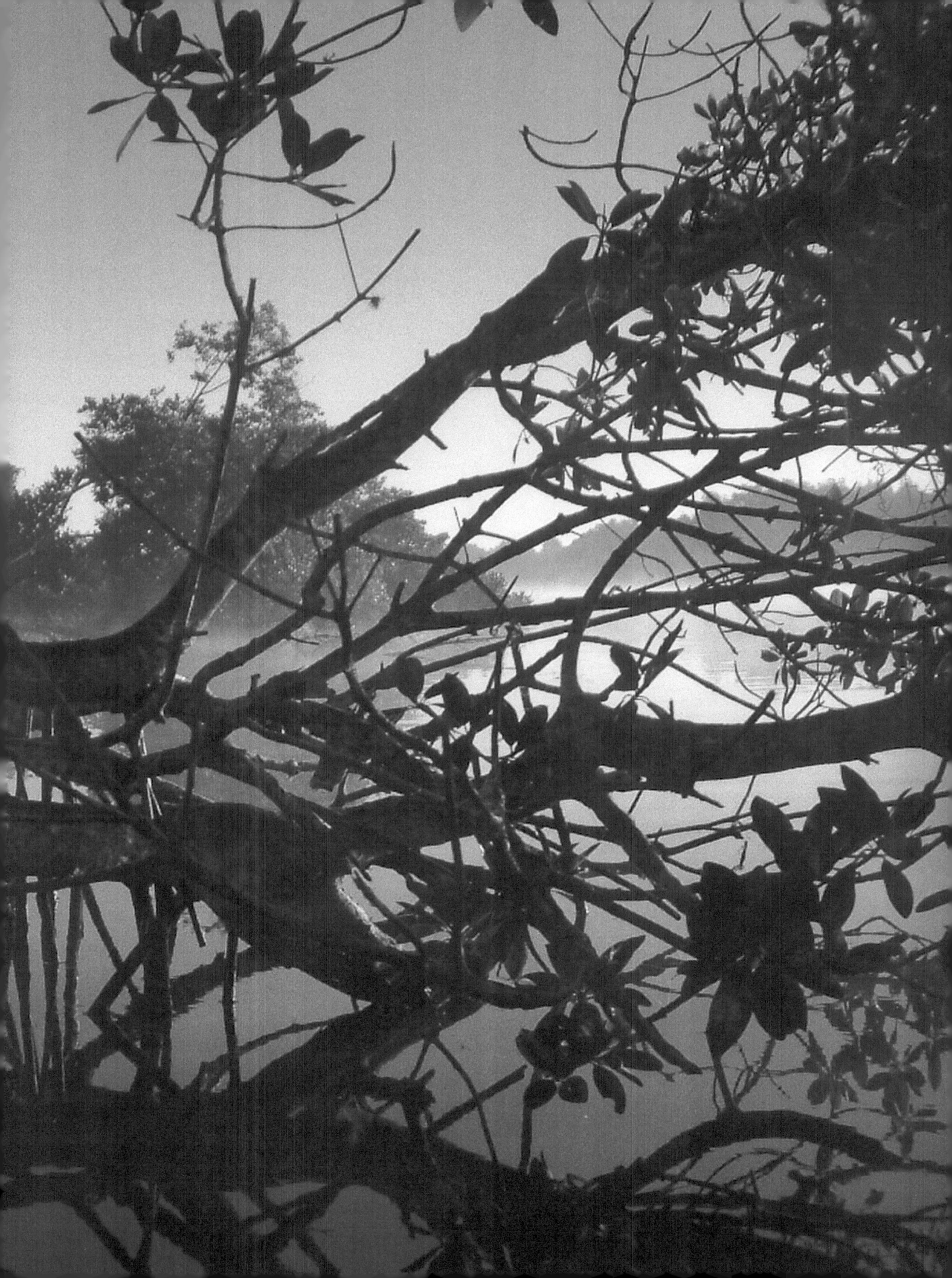

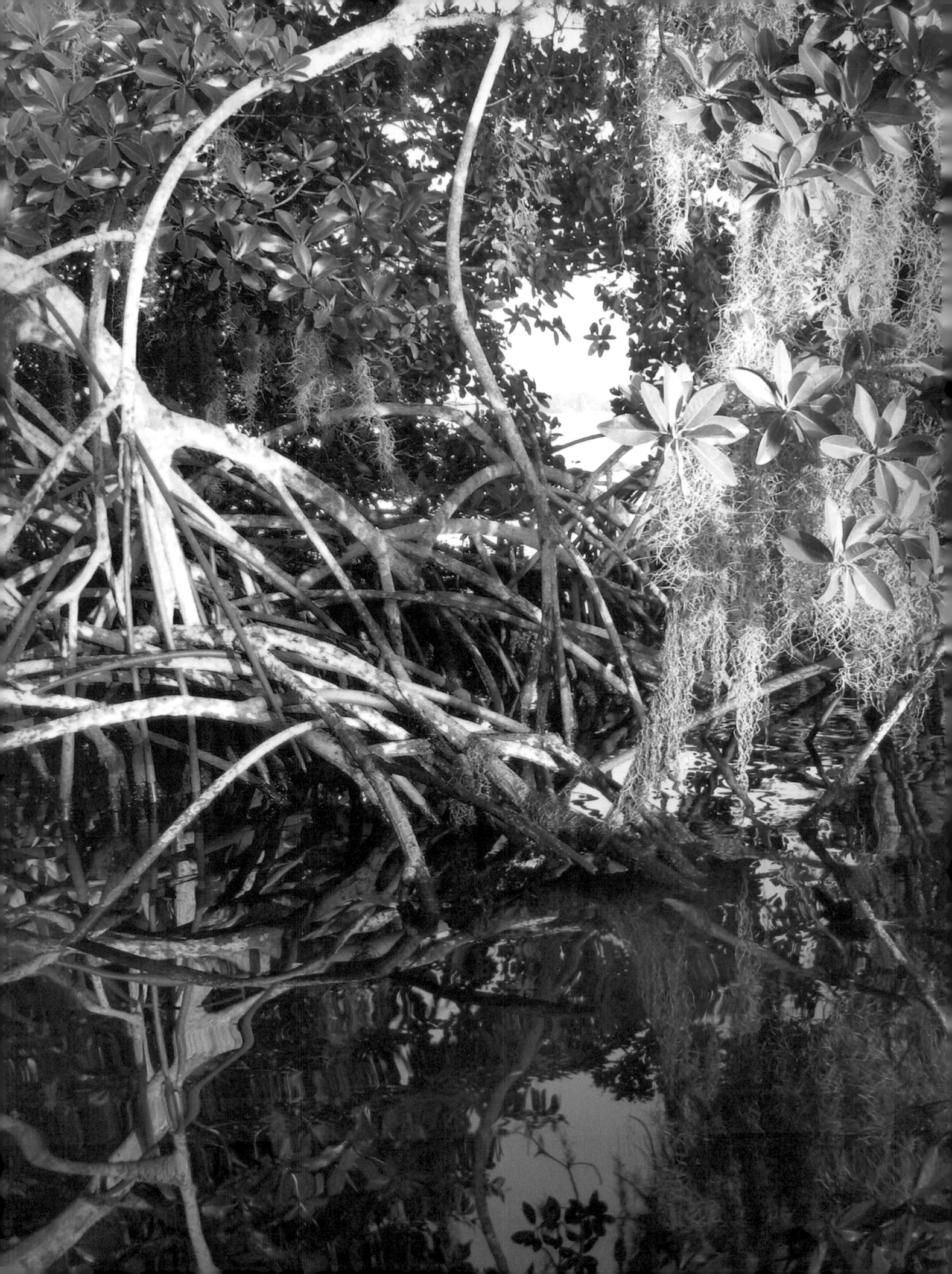

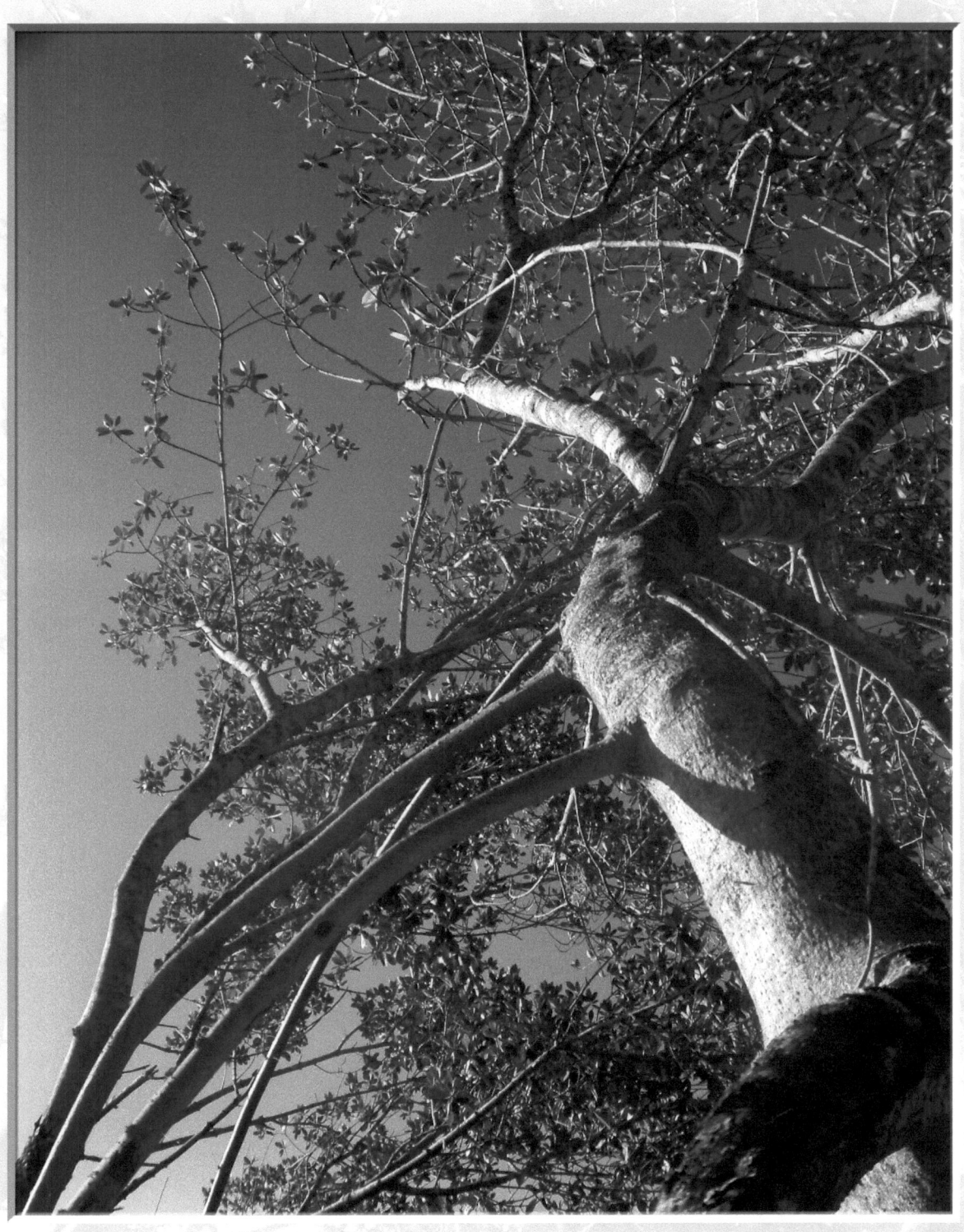

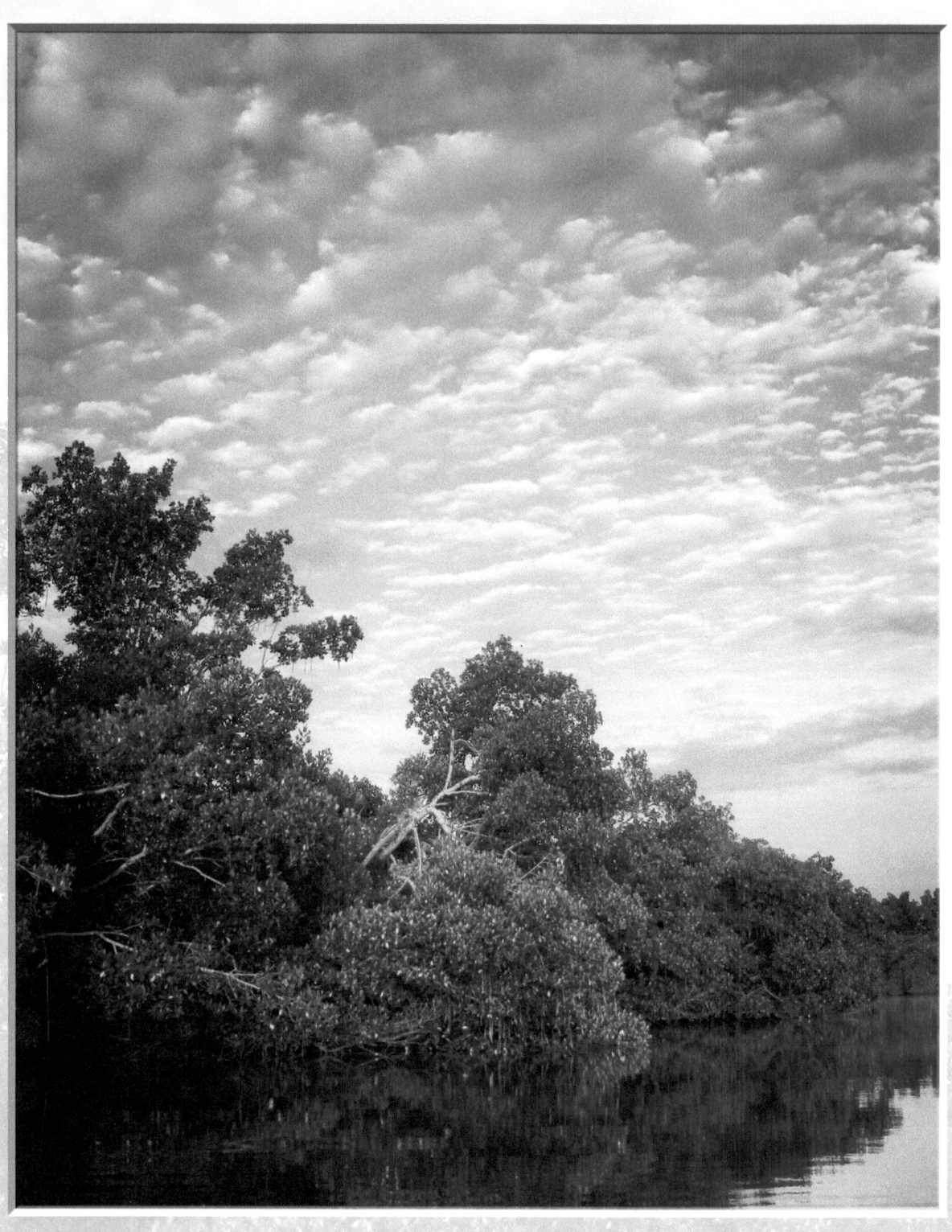

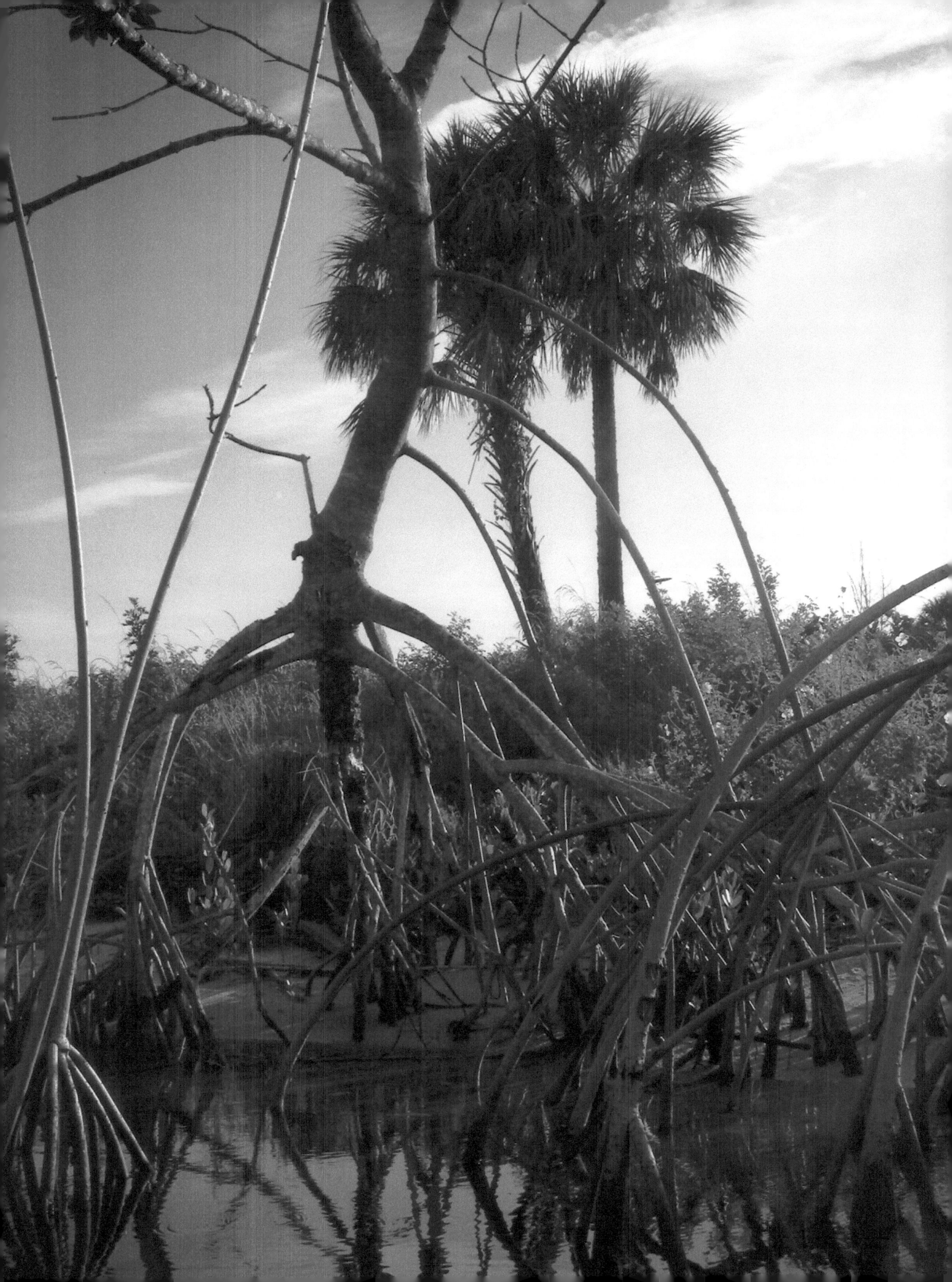

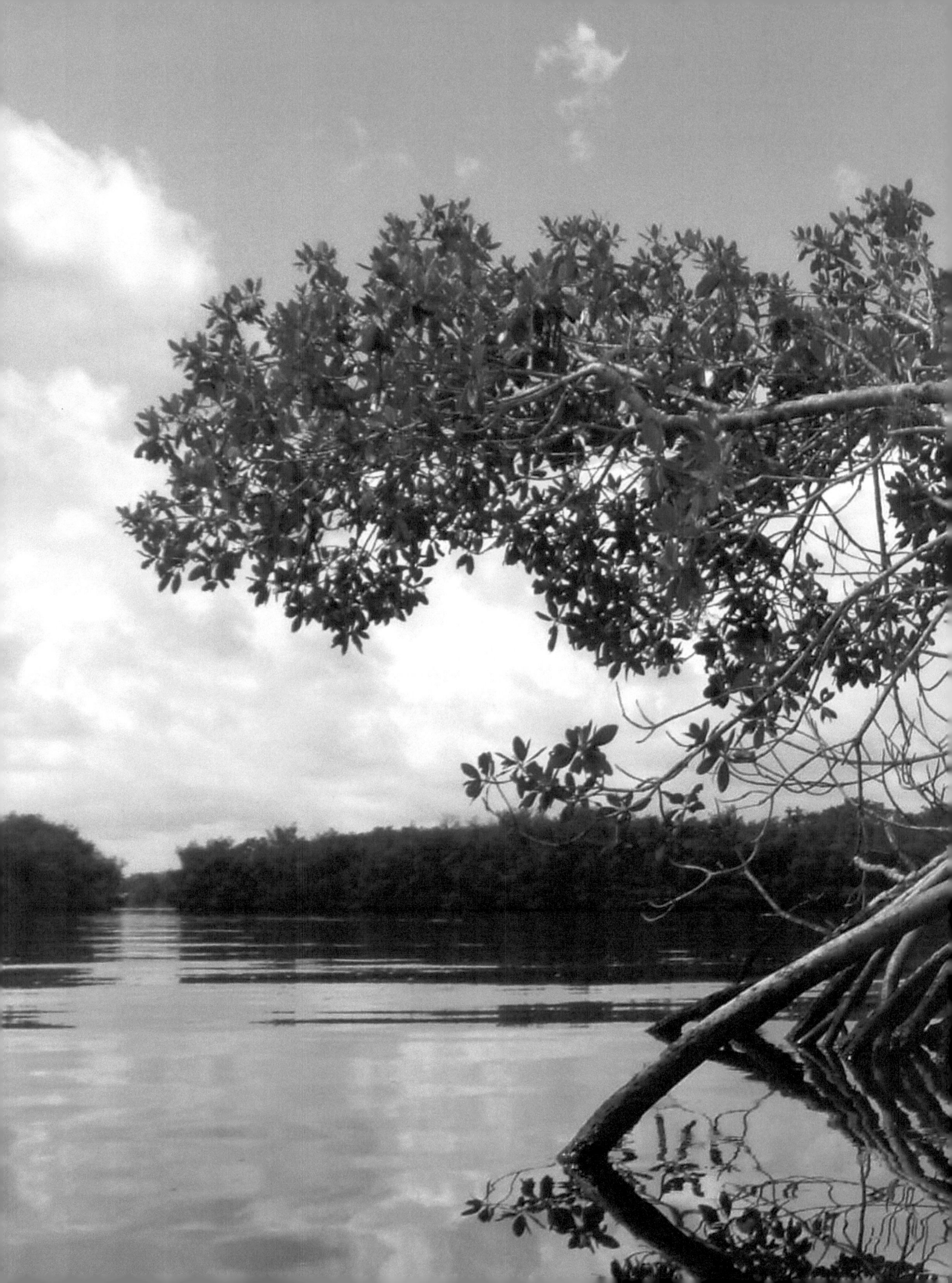

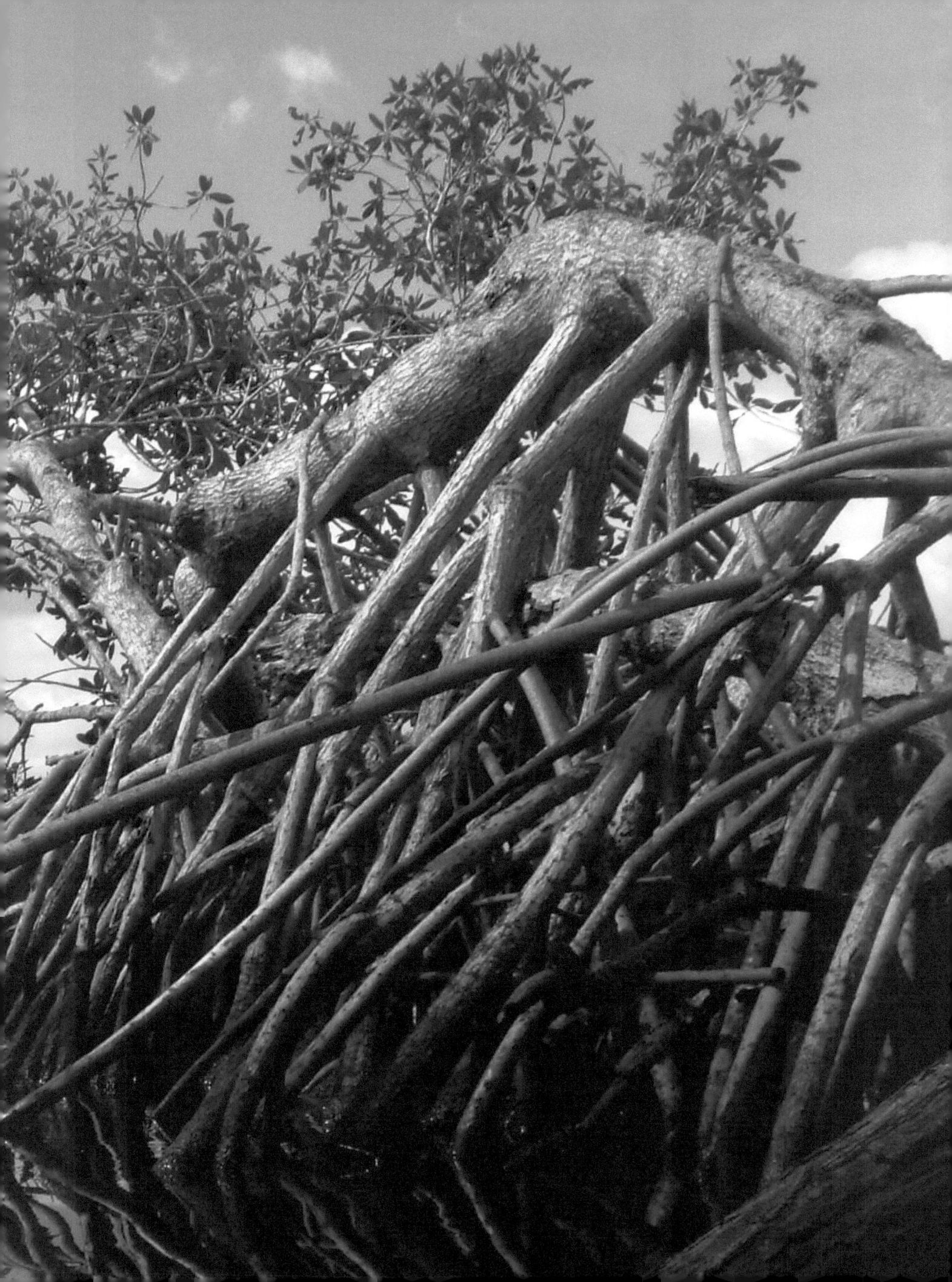

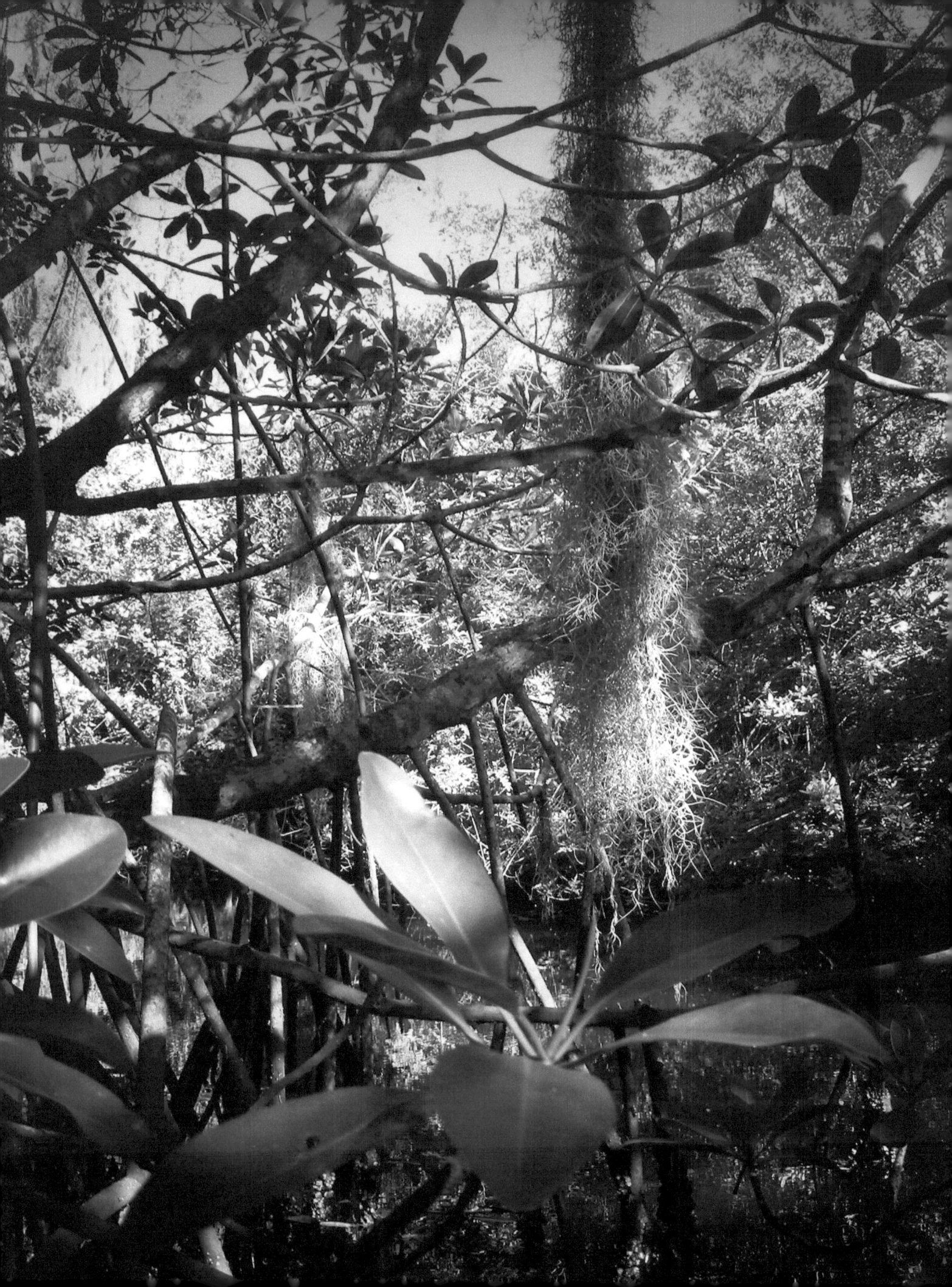

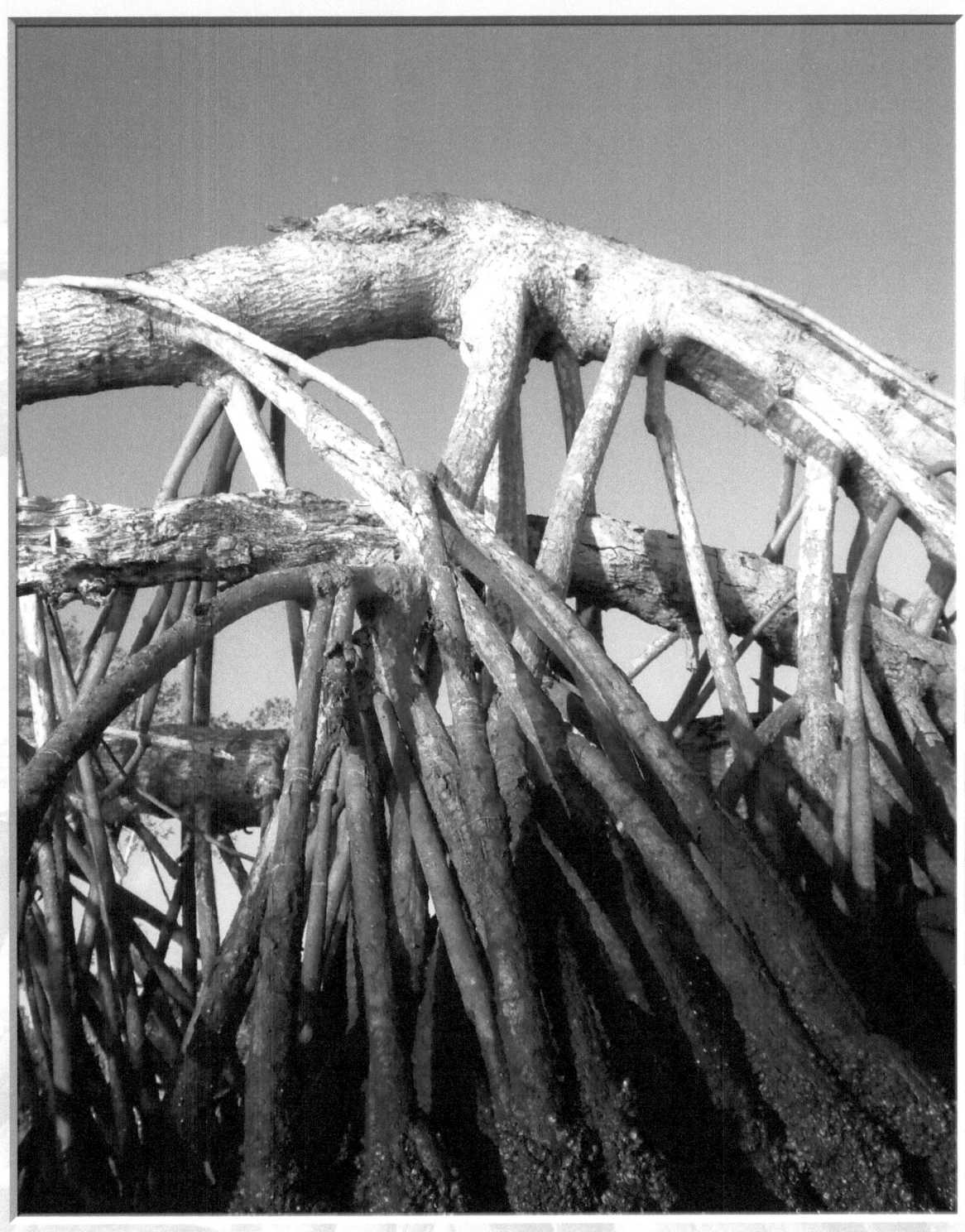

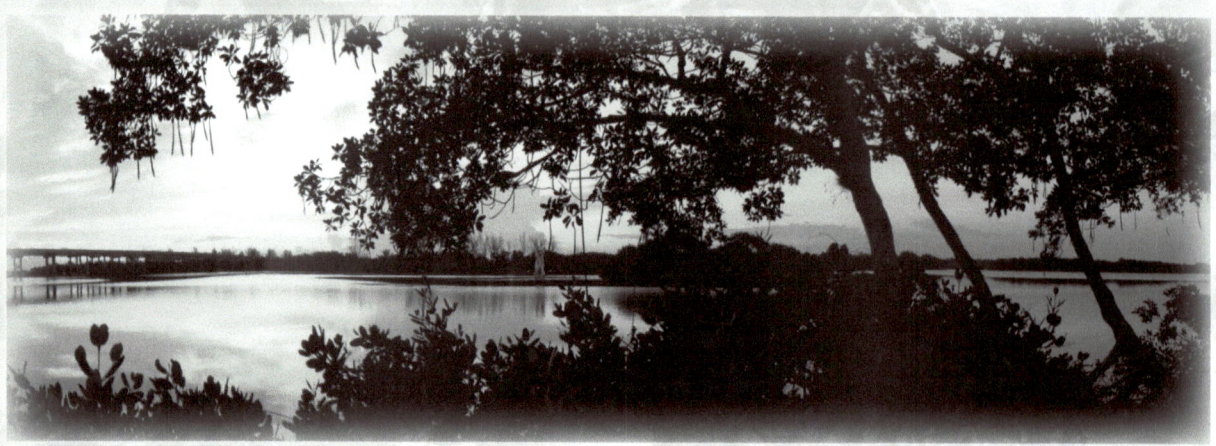

All the mangrove subjects and intracoastal habitat photographed in *The Mangroves* are centrally located near the Orange River's inlet into the Caloosahatchee River, at Fort Myers, Florida.

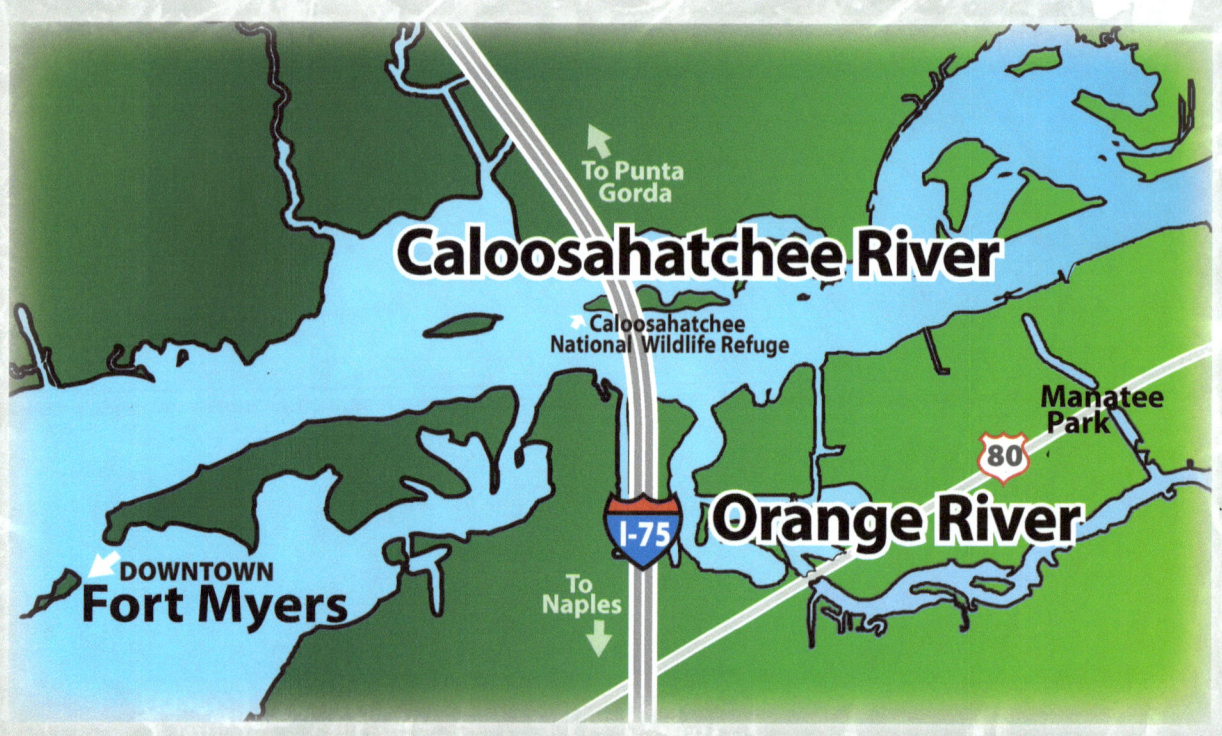

www.ingramcontent.com/pod-product-compliance
Lightning Source LLC
Chambersburg PA
CBHW050817180526
45159CB00004B/1695